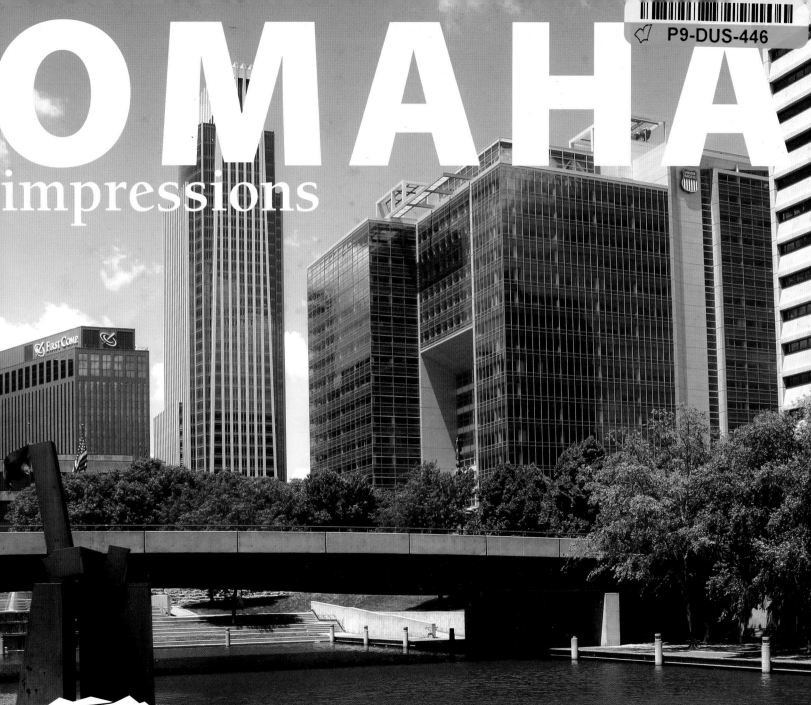

OMAHA
impressions

PHOTOGRAPHY AND TEXT BY **Mike Whye**

FARCOUNTRY PRESS

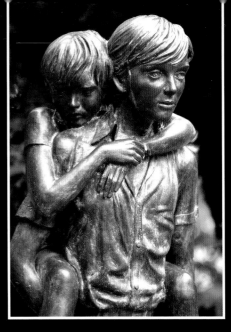

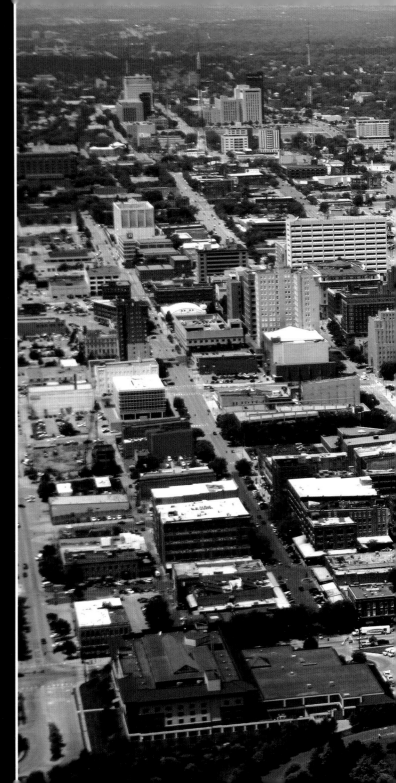

ABOVE: Three statues on the campus of Girls and Boys Town epitomize the saying, "He ain't heavy, Father…he's m'brother." The benevolent organization, located west of Omaha, was founded in 1917.

RIGHT: Gene Leahy Mall, at the base of the photo, is the largest municipal green space in downtown Omaha. It provides a welcome oasis of greenery away from the hubbub of city life.

TITLE PAGE: Omaha sprouted along the west bank of the mighty Missouri River. The waterway defines the state line between Nebraska and Iowa.

FRONT COVER: Near the Old Market, Heartland of America Park offers gondola rides that glide silently past the colorful light show of a fountain that arches in artful patterns.

BACK COVER: One of four distinctive metal towers on Abbott Drive welcomes all who come downtown from Omaha's Eppley Airfield.

ISBN 10: 1-56037-433-0
ISBN 13: 978-1-56037-433-6

© 2008 by Farcountry Press
Photography © 2008 by Mike Whye

For more information about our books, write Farcountry Press, P.O. Box 5630, Helena, MT 59604; call (800) 821-3874; or visit www.farcountrypress.com.

Created, produced, and designed in the United States.
Printed in China.

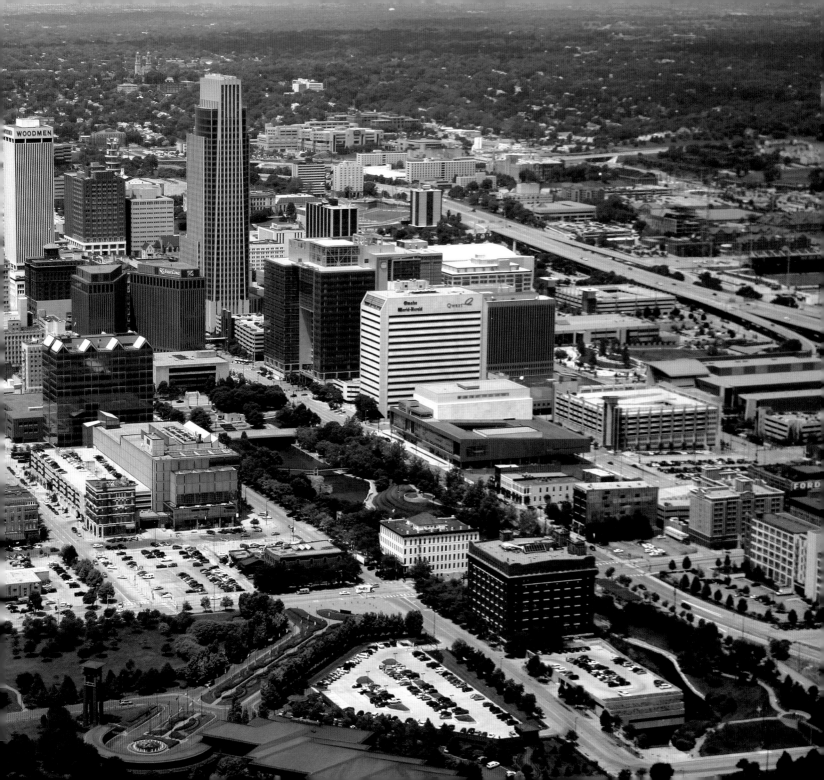

OMAHA

When I told people I was working on a photo book about Omaha, some of them good-naturedly asked, "What's to photograph around here?"

Others asked me that same question—and meant it. To them, I replied that the Omaha metropolitan area has a whole lot to show off.

There is so much about Omaha that is impressive. I say that because, although I've lived in the Omaha area off and on for at least 40 years, I can still see it from an outsider's view. Perhaps that's because I arrived here as an Air Force brat, able to compare it to other cities, larger and smaller, where I had lived. Perhaps it's because I work as a travel writer/photographer, and can contrast it with other communities, near and far, in the United States and the world.

The beauty of the Great Plains has always been subtle, nuanced. It challenges people to really look at what's here. There is great natural beauty in tasseled cornstalks that resemble tepees silhouetted against a stormy evening sky; clouds rambling across the setting sun before encircling the moon that shines over the winding Platte River; oaks rising tall with other trees, adorning the slopes of ravines, casting shadows across the undergrowth but illuminating the thoughts of those who see and appreciate them.

In other ways, we make the beauty that is here. Houses side by side in the Dundee area seem to be in lockstep, like a marching band following curving, tree-lined streets. Ornate details hammered and chiseled into century-old buildings stand next to new buildings sleek, tall, and reflective. In one of the world's largest aquariums, a ray

Well-kept barns shelter the agricultural operations at this farm near the Platte River, south of Omaha.

serenely glides over visitors in a clear tunnel that runs through the 900,000-gallon basin.

Then there's the beauty within the citizenry of Nebraska's most populous area. An actress flies into the night as Peter Pan, at the nation's largest community theater. Athletic young women pause at their oars as they head toward the rising sun. On summer evenings, musicians and singers on the pink marble steps of the city's largest art museum entertain thousands.

People who see me photographing in and around Omaha are often curious. One evening, on Zorinsky Lake in west Omaha, a bicyclist paused to talk, and said she hadn't been downtown for years. Likewise, some folks I met downtown said they had little idea how other parts of Omaha look. I hope this book encourages those people and others to see something new about where we live, and realize the beauties are widespread.

I also hope this book introduces visitors to the splendors of Omaha, and helps them understand that it is more than just one city. The metro area encompasses independent communities such as Ralston, Papillion, La Vista, and Gretna, each with a unique identity. Elkhorn, Benson, Dundee, Florence, and Millard once were autonomous cities, now annexed by their larger

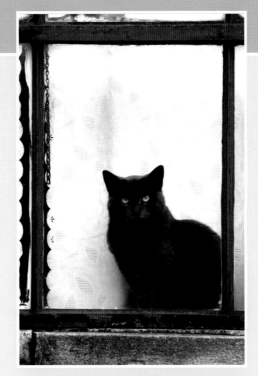

A curious cat in the Bemis Art Center studio finds good viewing at a window.

neighbor as it grew across Douglas County. Nevertheless, they maintain their distinctive personalities as neighborhoods. Bellevue, Nebraska's oldest city, harbors traces of an early nineteenth-century trading post in the shade of Fontenelle Forest, while just a few miles away military aircraft with ultra-modern communications gear take off and land at Offutt Air Force Base. East, across the Missouri River, lies the region's second largest city: Council Bluffs, Iowa. Those residents spawned Omaha in the 1850s, not long after creating their own community. Little did they know then that their younger sibling, named after the Native Americans who had occupied the region where skyscrapers now stand, would outgrow them in a few decades.

Every year, visitors tell Omahans how lucky we are to live in such a wonderful city. They're right. The metro area has a good economy and a fantastic quality of life. One of the world's richest men lives here—what does that say? Omaha lies near the center of the United States, geographically and in the core of its soul as well.

Welcome to these impressions of Omaha. It is a great place, a beautiful place.

—Mike Whye

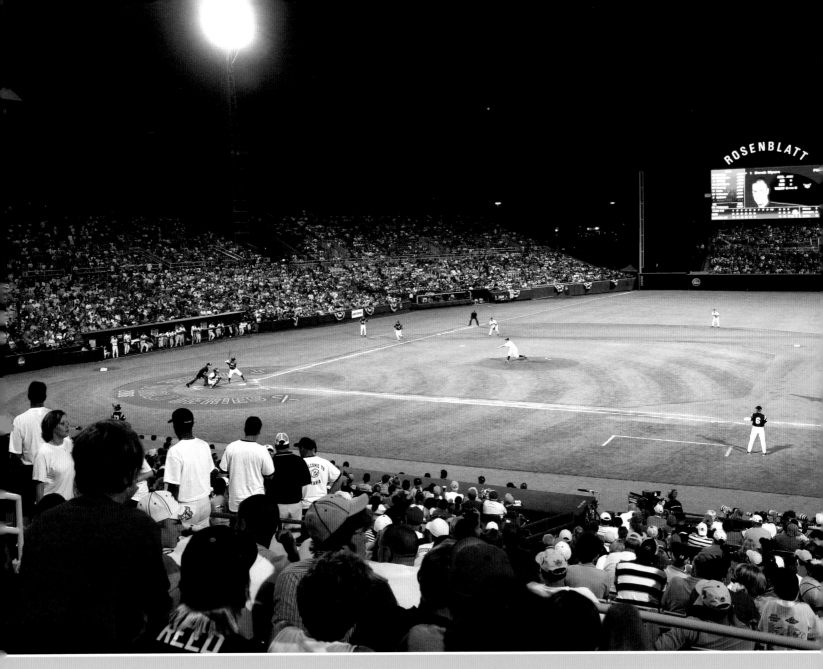

ABOVE: Rosenblatt Stadium is home turf to the Omaha Royals, a AAA farm team of the Kansas City Royals. In addition, Rosenblatt has hosted the NCAA Men's College World Series since 1950. Pictured here, more than 30,000 fans from across the nation watch the June 21, 2006 NCAA game between Rice University and Oregon State University.

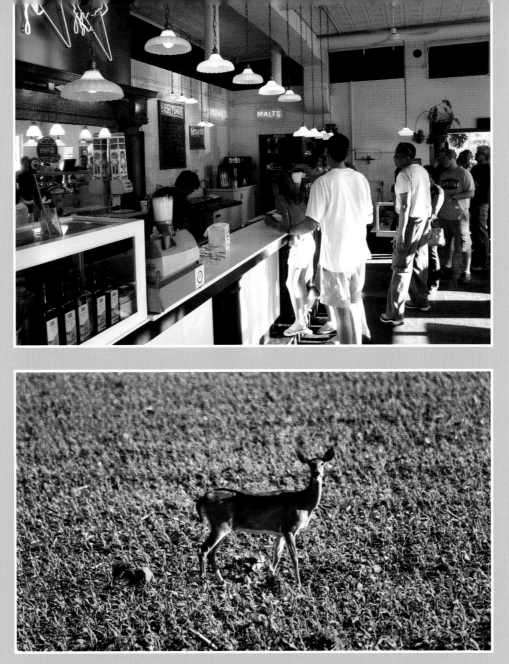

ABOVE, TOP: Eager customers line up for homemade ice cream at Ted and Wally's Ice Cream Shop. Ted and Wally's began serving its cold treats in 1986 in the Old Market.

ABOVE, BOTTOM: A white-tailed deer pricks up her ears while browsing through a Sarpy County field.

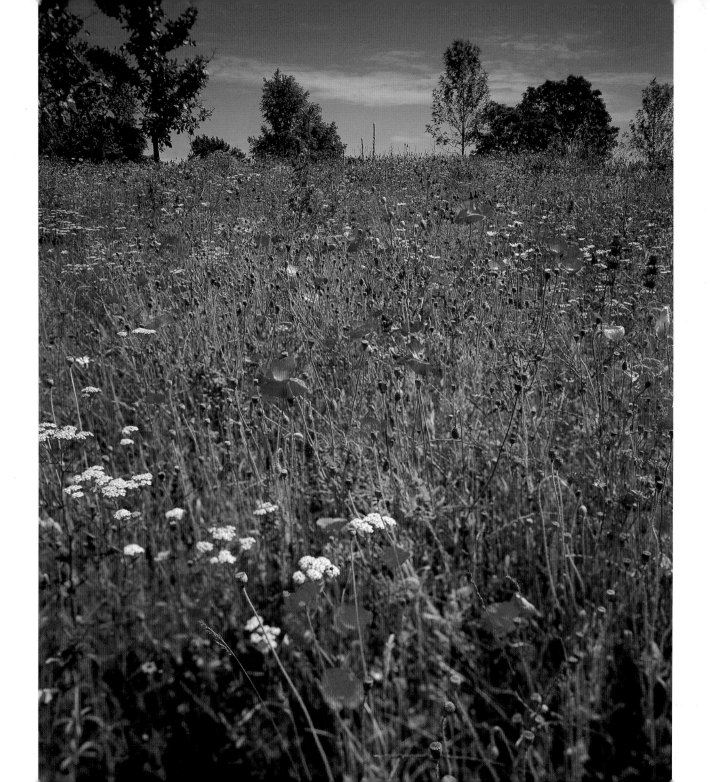

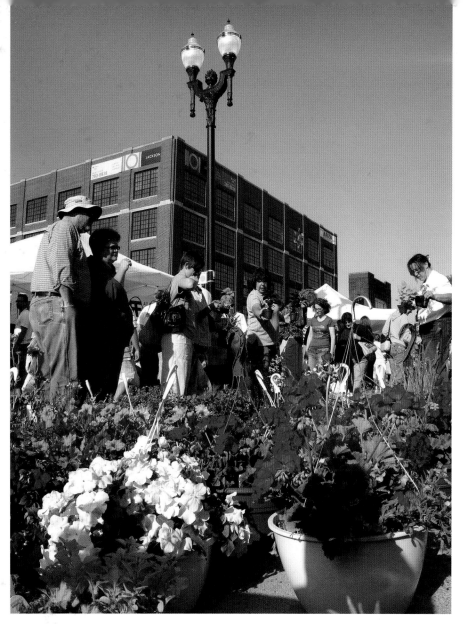

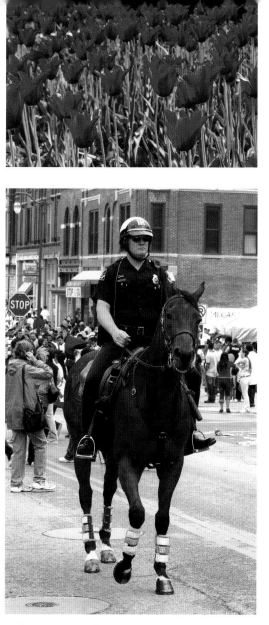

ABOVE: Baskets of petunias and other flowers entice shoppers in the Old Market. The Old Market encompasses several blocks of renovated brick warehouses and unique storefronts. This historic area of town has been revitalized into a thriving arts, entertainment, and residential district.

FACING PAGE: An array of wildflowers fills a small city park in western Council Bluffs, recalling an era when the prairie covered this region from horizon to horizon.

ABOVE, TOP RIGHT: Tulips put on their best colors at Lauritzen Gardens, Omaha's Botanical Center. The first rose garden was planted in 1995, and from that modest beginning it has grown to include 100 acres of diverse plantings, including a Victorian garden, a festival garden, and a woodland trail.

ABOVE, BOTTOM RIGHT: One of Omaha's seven mounted police officers guides his horse through a crowd after a Cinco de Mayo parade in South Omaha.

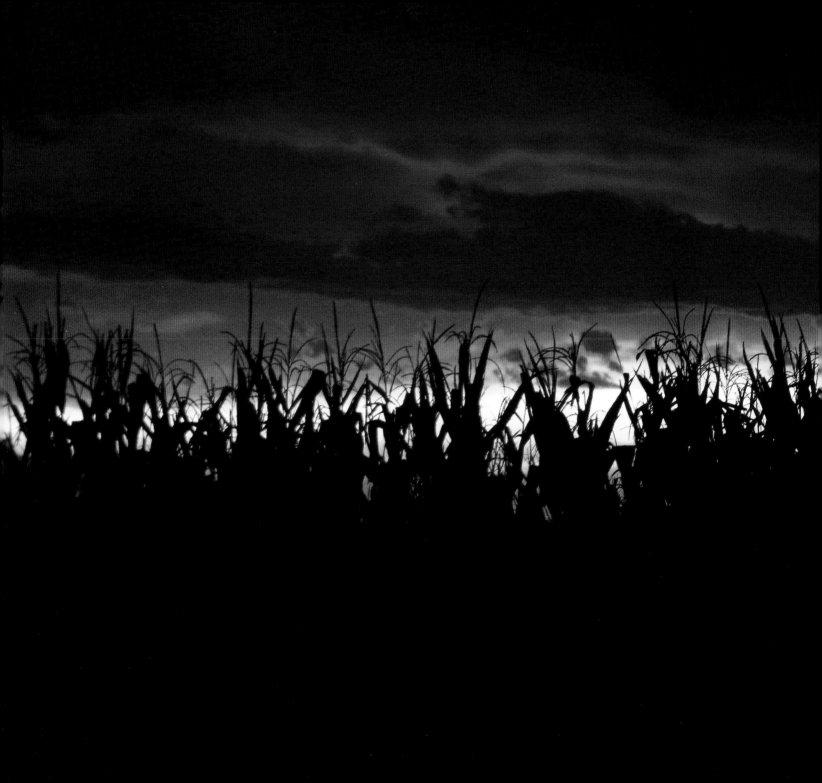

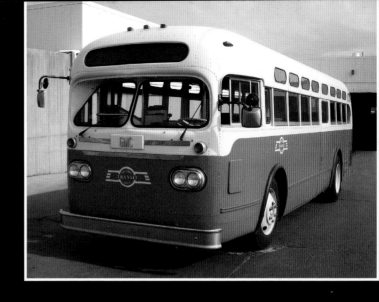

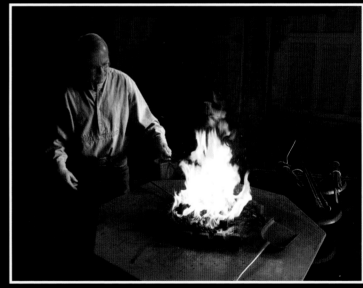

ABOVE, TOP: Metro Area Transit operates a handful of classic buses, some up to 50 years old. MAT modernized the vehicles while keeping the retro colors and styles of yesteryear.

ABOVE, BOTTOM: An artist works at Loken Forge, one of the founding firms of the Hot Shops Art Center. Because Loken, Bruning Sculpture, and the Crystal Forge each use heat in their operations, they coined the name Hot Shops for the former mattress factory they occupied in 1999.

LEFT: With a little imagination, these cornstalks form a village of tepees silhouetted against the western sky following a summer thunderstorm.

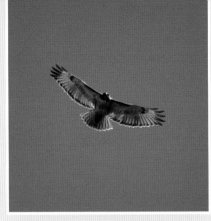

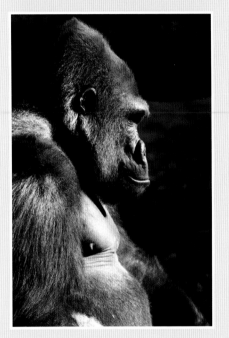

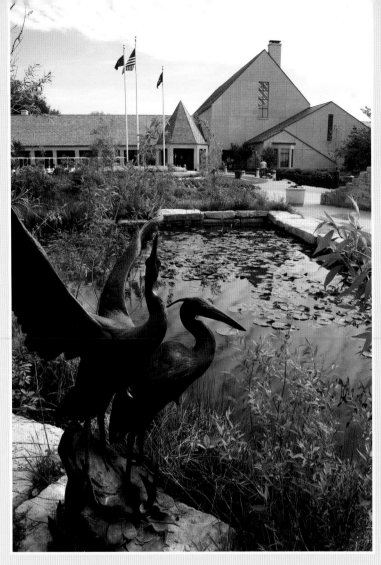

ABOVE, TOP: Adapted to civilization, a red-tailed hawk soars above a south Omaha neighborhood as it searches the open spaces below for prey.

ABOVE, BOTTOM: A silverback gorilla basks in a ray of sunlight at Henry Doorly Zoo. The innovative Hubbard Gorilla Valley complex allows people to safely walk through an area where gorillas walk alongside, under, and above the visitors. More than 1.5 million people visit the zoo each year.

ABOVE: The welcoming entrance to Lauritzen Gardens sports a bronze figure of great blue herons, sculpted by Bob Guelich, next to a pond decked with water lilies, lotus, and tropical blue water lily.

FAR RIGHT: Union Pacific Railroad opened Union Depot in 1931; for decades, up to 10,000 passengers from numerous railroad companies passed through its doors daily. The Art Deco structure now houses the Durham Western Heritage Museum, showcasing displays on the history of Omaha and regions to the west.

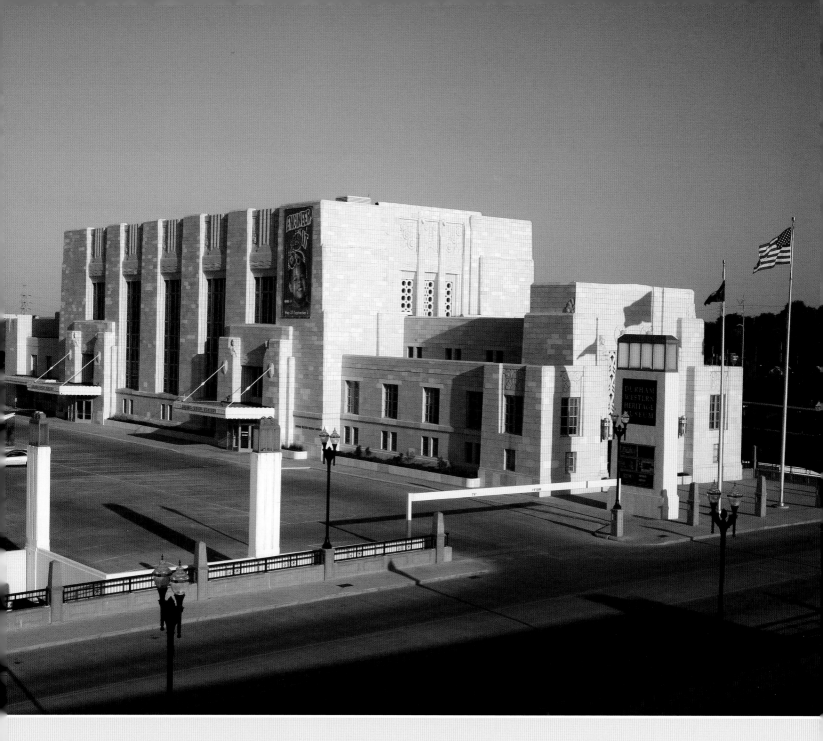

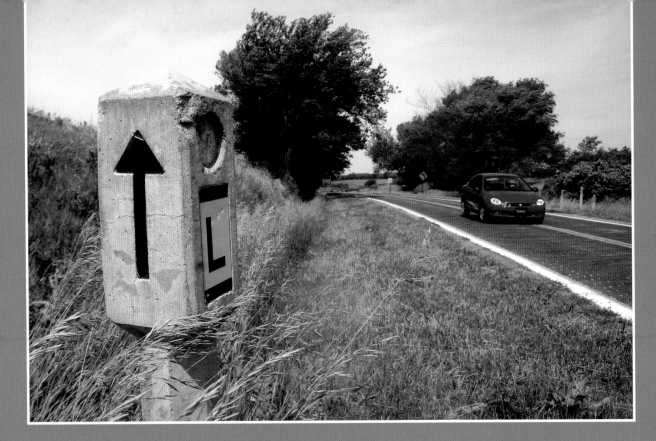

ABOVE: The Lincoln Highway was the nation's first transcontinental highway. This three-mile segment east of Elkhorn was paved with bricks in the 1920s.

RIGHT: Freshly picked radishes are bunched and ready for sale, brightening a table of produce on a Saturday morning farmer's market in the Old Market.

FAR RIGHT: Farms and hay fields lie just a few miles from Omaha's buildings and suburbs.

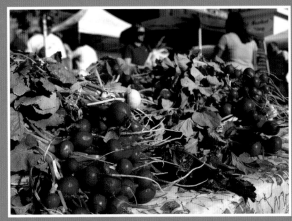

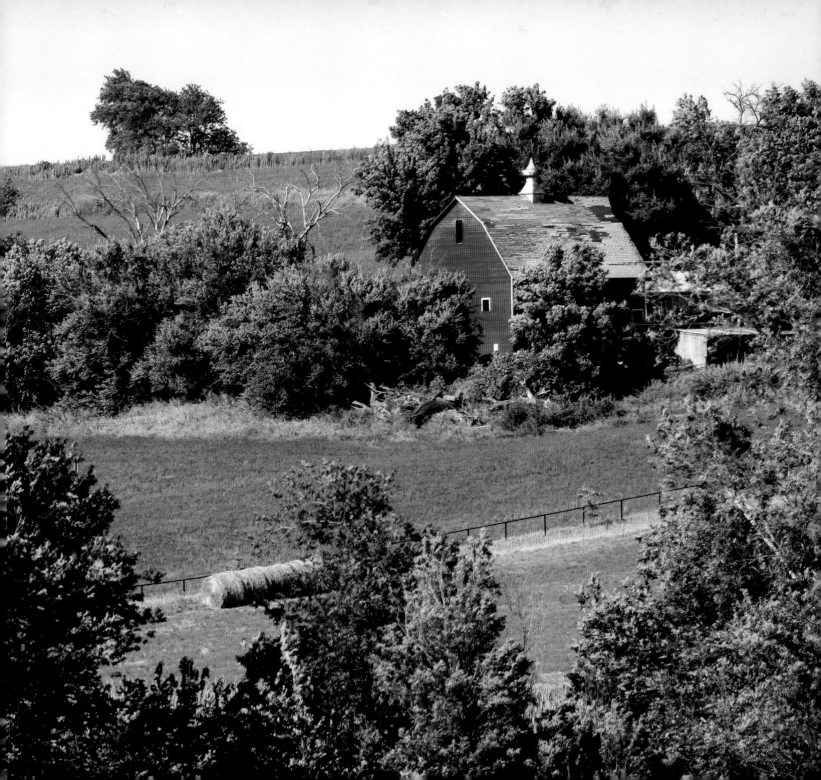

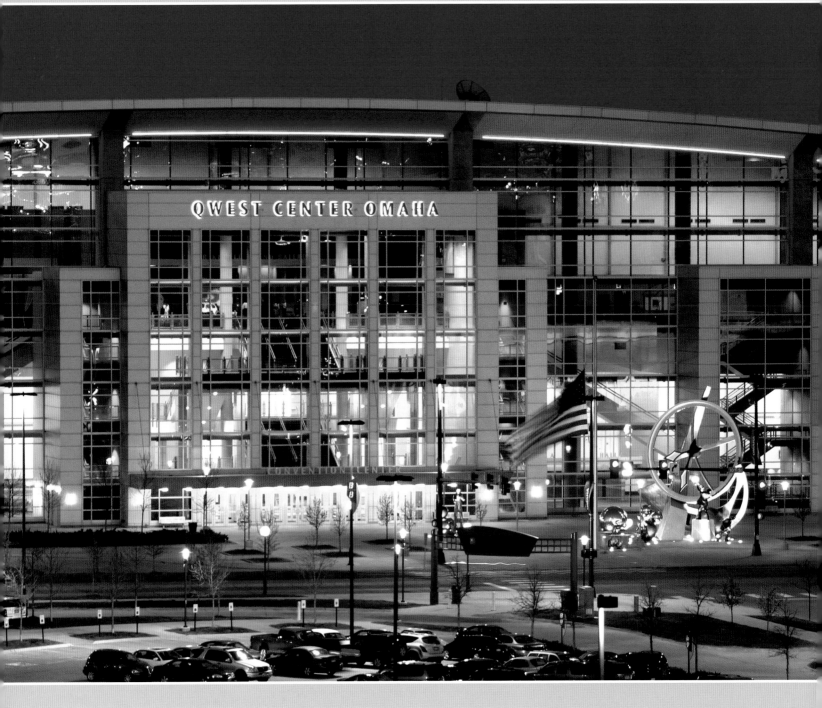

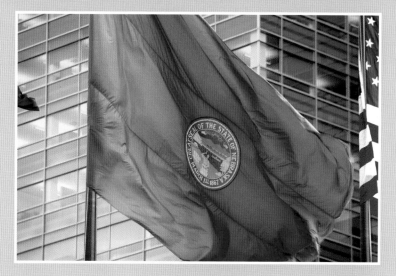

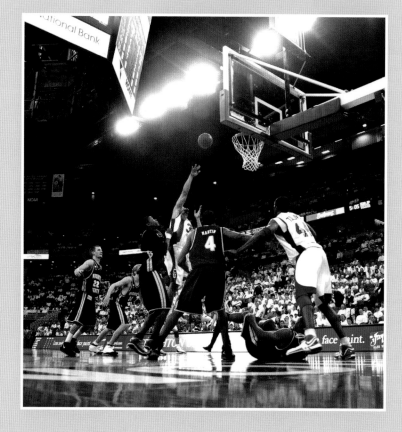

LEFT, TOP: The Nebraska flag billows in a breeze in downtown Omaha. The state motto on it reads, "Equality Before the Law."

LEFT, BOTTOM: Qwest Center Omaha hosts the home games of the Creighton University men's basketball team, seen here in an action-packed moment. The facility hosts other sporting events, too. On December 16, 2006, 17,209 people formed the largest crowd ever to watch an NCAA volleyball game (University of Nebraska at Lincoln won the championship).

FAR LEFT: Qwest Center Omaha glows in the evening twilight. Pollstar, a concert tracking firm, ranked the convention center and arena as high as fifth in the nation for the number of concert tickets sold.

RIGHT, TOP: A U.S. Post Office is one of 32 buildings that form the South Omaha Main Street District. Prior to being annexed by Omaha in 1915, South Omaha had been a separate city with about 35,000 residents; the meat packing industry was its economic mainstay. For several years, South Omaha was called the Magic City because of its rapid growth.

RIGHT, BOTTOM: Big Boy, originally operated by Union Pacific, is one of the world's largest steam locomotives. With its tender loaded, Big Boy weighed 1.2 million pounds. Now retired, it rests on a display trestle along with the world's largest diesel-electric locomotive. These engines alongside Interstate-80 welcome eastbound travelers to Omaha.

FACING PAGE: Magnolia blossoms color a spring day pink, next to the former home of businessman George Joslyn and his wife Sarah. The 35-room home, named Lynhurst by the Joslyns and now called the Joslyn Castle, was built in 1903 at a cost of $250,000. Various trees on the grounds, including some planted by the Joslyns, constitute an affiliate site of the Nebraska Statewide Arboretum.

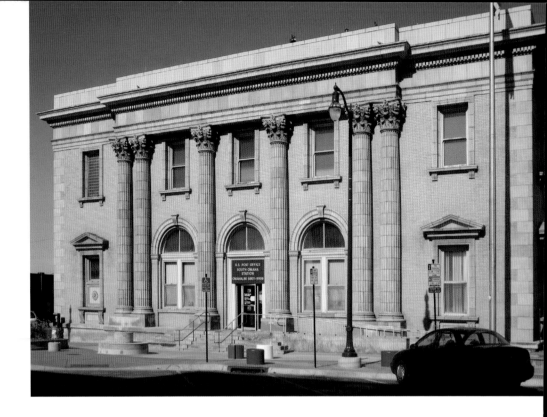

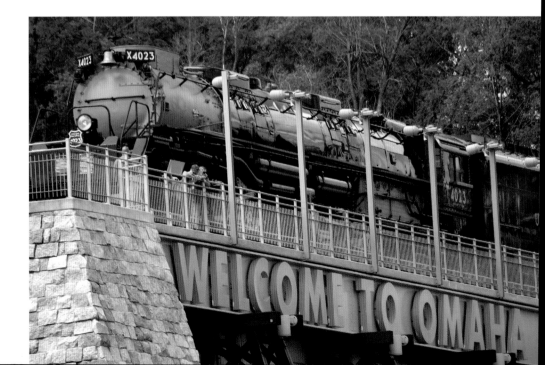

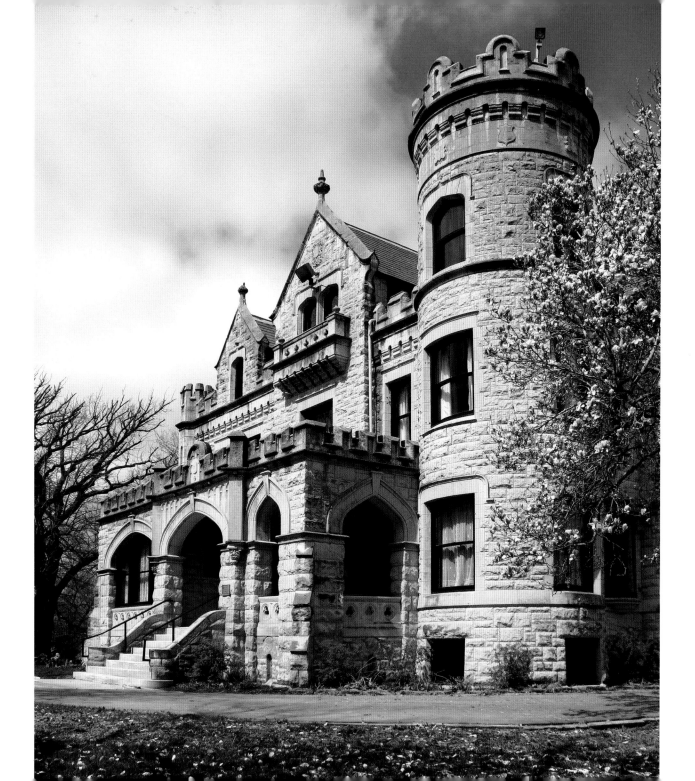

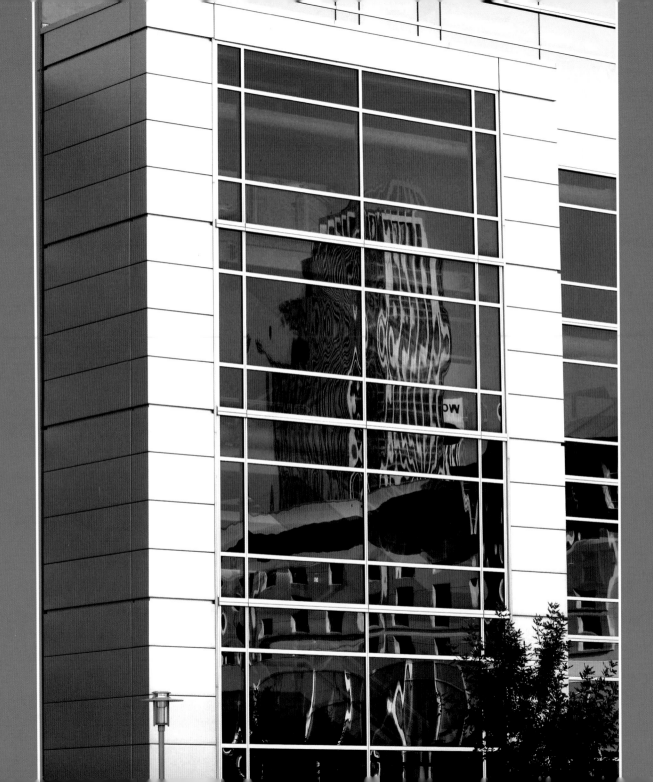

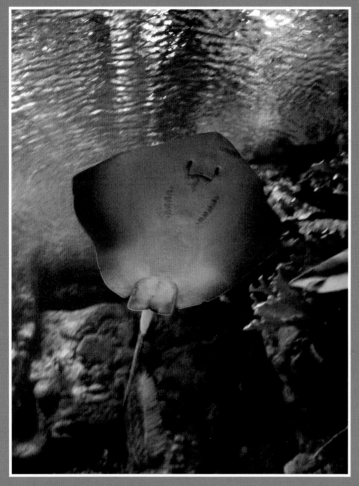

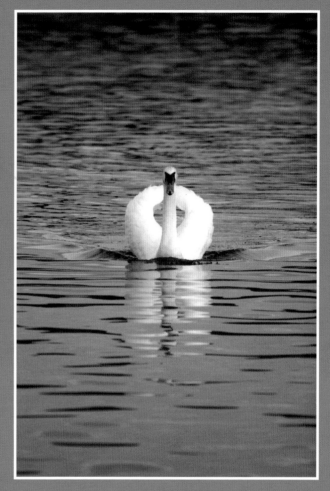

ABOVE: A ray glides through the 900,000-gallon saltwater tank in the Henry Doorly Zoo aquarium. The tank features a 70-foot-long acrylic tunnel through the water that allows people to walk right into the exhibit. Begun in 1894, the zoo has the world's largest indoor rainforest, as well as a nocturnal exhibit, and an exhibit representing the deserts of America, Australia, and Africa. In 2004, *Readers Digest* ranked this zoo as the best in the nation.

ABOVE: A swan folds its wings in perfect symmetry and glides across the pond in Heartland of America Park.

FACING PAGE: Like the mirrors in a funhouse, downtown windows reflect distorted images of surrounding buildings.

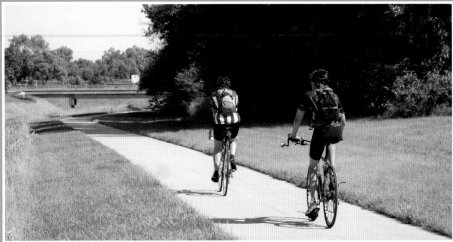

ABOVE, TOP: Drawn to the placid water, visitors to downtown's Heartland of America Park relax near the lake.

ABOVE, BOTTOM: Two bicyclists wheel down the Keystone Trail, one of more than two dozen hike-and-bike trails that make up a system more than 120 miles long. The routes will eventually connect with trails in Lincoln, 50 miles southwest, and Council Bluffs, Iowa, across the river.

RIGHT: Gently curving streets are a signature feature of this Dundee area, considered Omaha's first suburb. On April 18, 1945, one of the 9,000 balloon bombs launched by Japan exploded in the sky above the neighborhood, causing little damage. Military authorities forbid publishing information about the attack until after World War II ended to prevent the Japanese from knowing that their bombs had reached the United States.

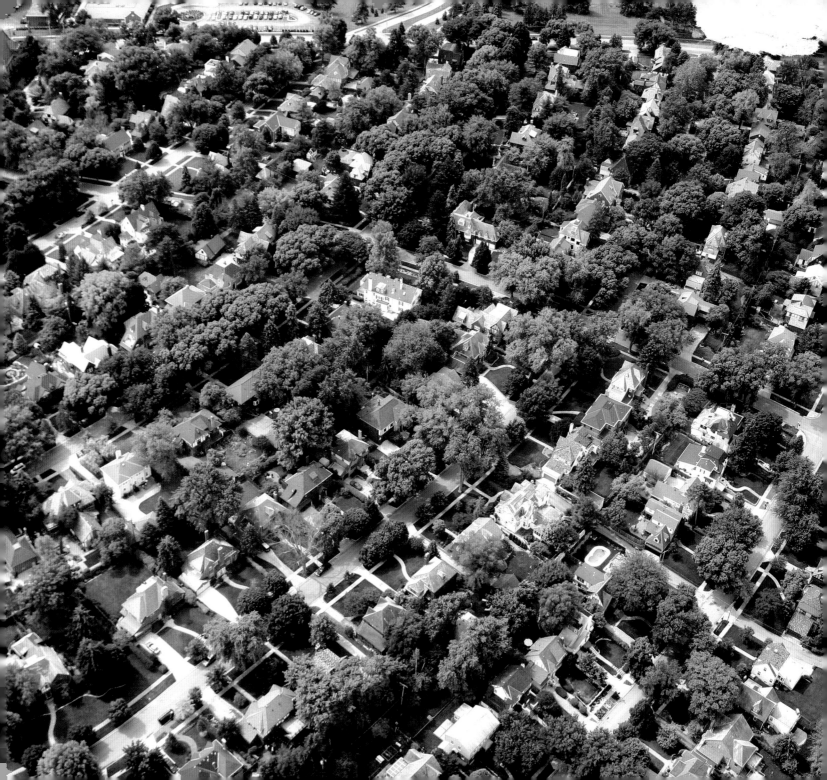

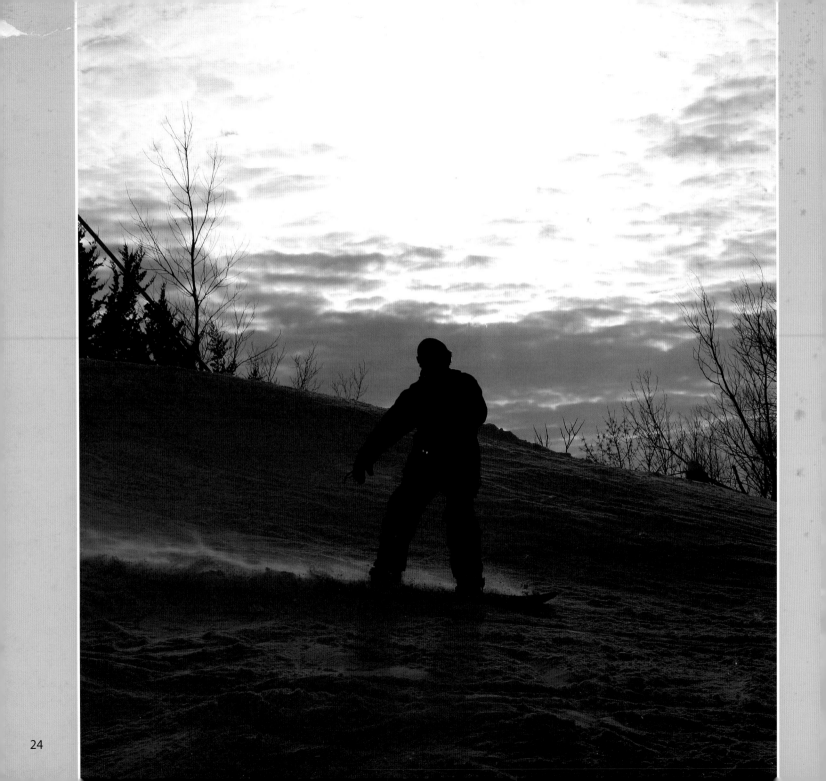

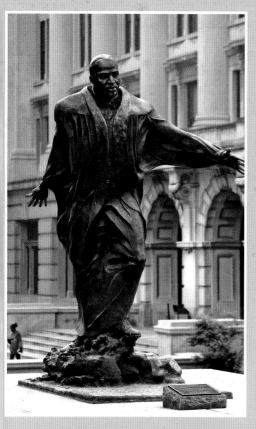

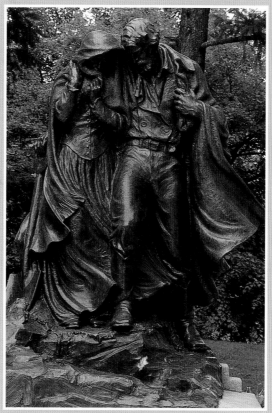

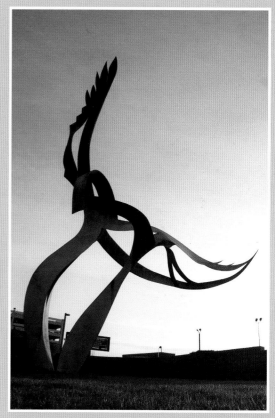

ABOVE, LEFT: A nine-foot-tall statue titled *Rev. Dr. Martin Luther King, Jr.: I've Been to the Mountain Top,* sculpted by Littleton Alston, rises larger than life in Farnam Street Civic Center Plaza, near the Douglas County Courthouse.

FACING PAGE: A snowboarder cruises down one of the slopes at Mt. Crescent Ski Area in Iowa's Loess Hills, north of Council Bluffs.

ABOVE: Avard Fairbanks' sculpture depicts parents grieving the loss of their infant son. It stands in the Mormon Cemetery in northern Omaha, which holds the remains of more than 325 people who died on their way west in the 1840s.

ABOVE: *Dance of the Cranes,* by John Raimondi, gracefully welcomes people driving to Eppley Airfield. Standing 60 feet tall and weighing 15 tons, the stylistic depiction of two sandhill cranes was the largest bronze sculpture in North America when it was installed in 1988.

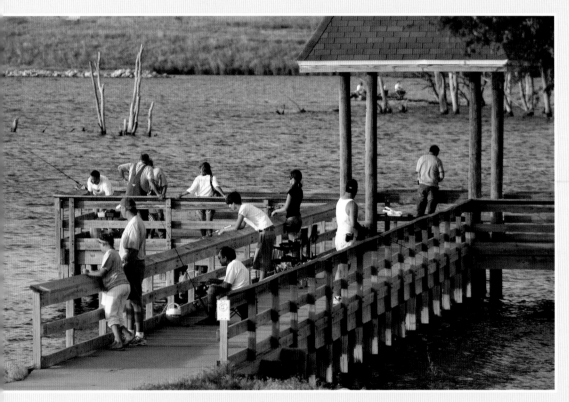

ABOVE: Residents come to fish or just plain loaf at a pier on 105-acre Walnut Creek Lake, southwest of Papillion, one of the smaller cities that is part of the metro area.

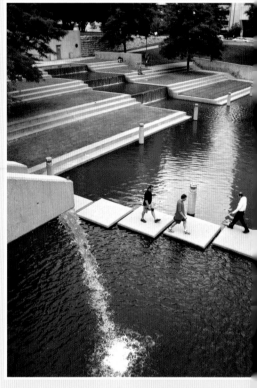

ABOVE: Visitors to Gene Leahy Mall find varying aural and visual perspectives on the interactions between water and concrete.

FACING PAGE: Buildings from various architectural eras form a wall of concrete, glass, brick, and steel in downtown Omaha.

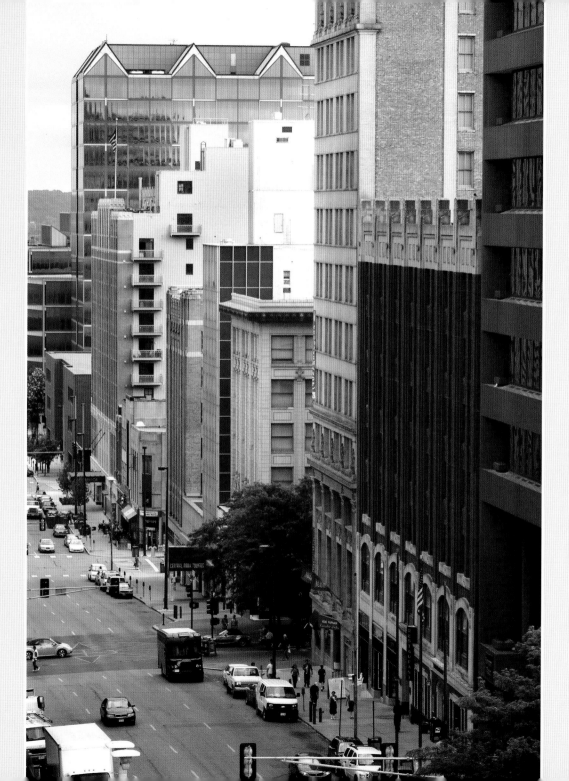

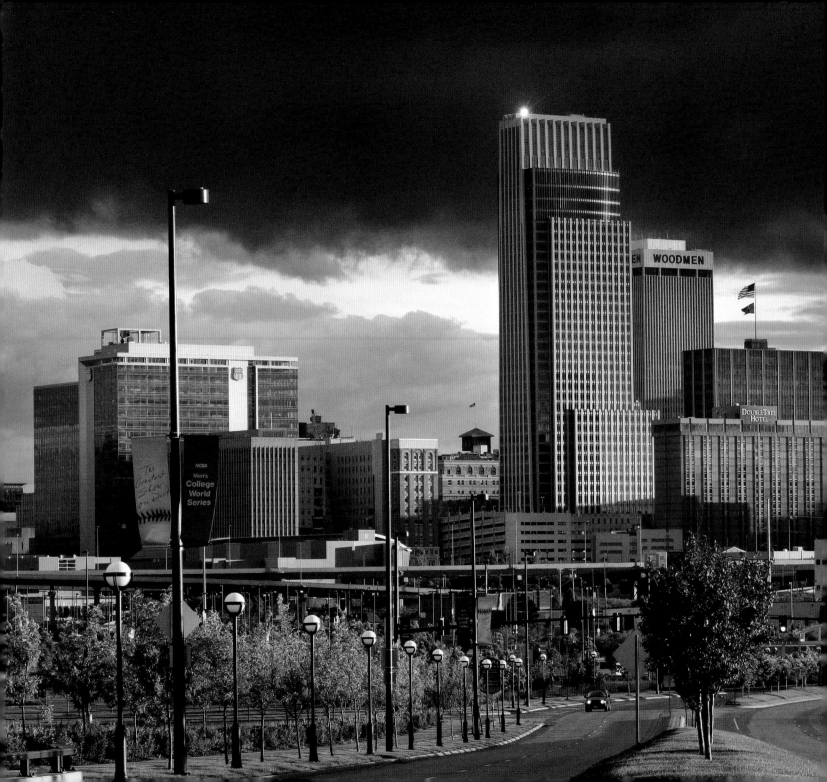

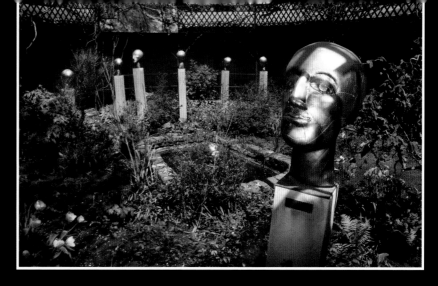

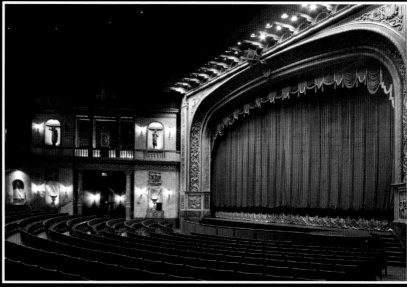

ABOVE, TOP: One of several heads created by Swiss artist Eva Aeppli reflects a striking gleam in the Garden of the Zodiac, an art space in the Old Market.

ABOVE, BOTTOM: The elegance of a past era remains vibrant in the Rose Theater. Called the Riviera Theater when it opened in 1927, it first hosted live performances, then served as a movie theater until the Omaha Theater Company acquired it to host live plays and musicals by and for children.

LEFT: Downtown Omaha glows beneath the dramatic contrasts of sunlight and dark thunderclouds at the end of a stormy day.

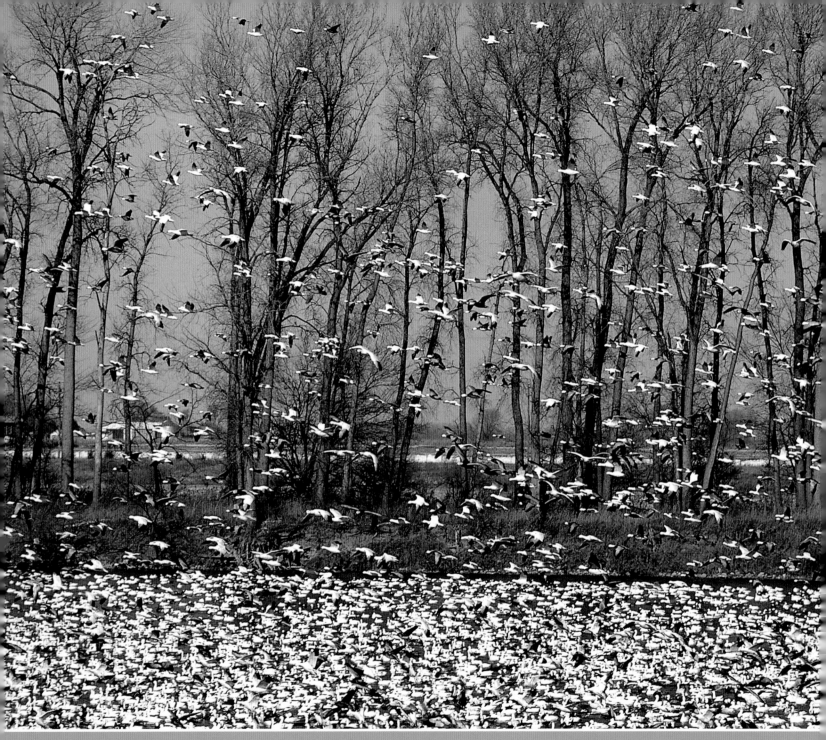

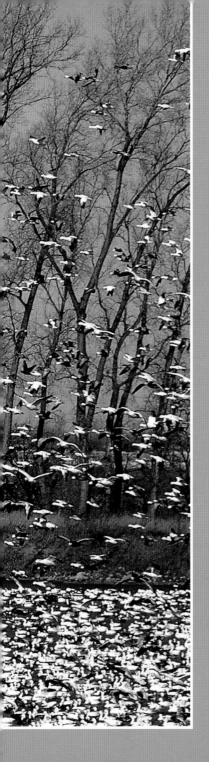

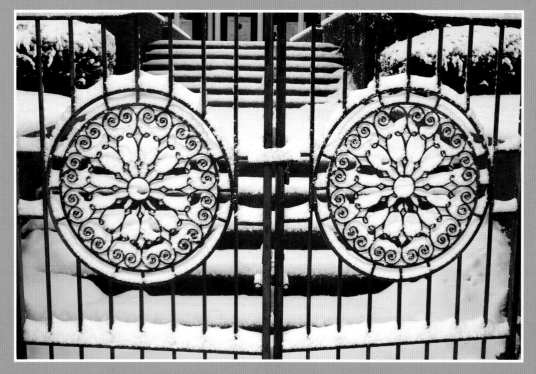

ABOVE: Wet snow clings to intricate wrought iron gates at the President Gerald R. Ford Birthsite and Gardens, near Hanscom Park. The nation's 38th president was born here on July 14, 1913 as Leslie Lynch King, Jr., not long before his parents parted. His mother took him to Michigan and three years later married Gerald Rudolph Ford, who adopted the boy and renamed him Gerald R. Ford, Jr.

LEFT: Like a flurry of snowflakes, a cloud of snow geese takes wing at DeSoto National Wildlife Refuge, north of Omaha. Late each fall, nearly a half million snow geese seek shelter here during their long migration south.

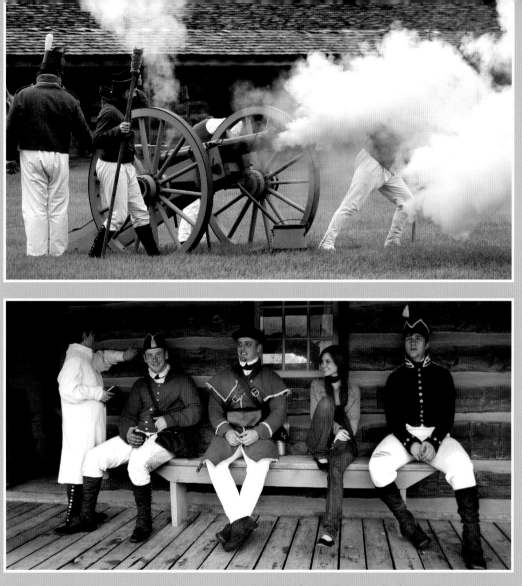

ABOVE, TOP: Re-enactors at Fort Atkinson State Historical Park fire a cannon on the fort's parade ground as part of the formal retreat to mark the end of a day.

ABOVE, BOTTOM: A thoroughly modern young woman looks pleased about sitting amid re-enactors at Fort Atkinson State Historical Park. The fort was built near the bluff where Captains Meriwether Lewis and William Clark met with six representatives of the Oto and Missouria tribes on their way up the Missouri River in 1804. The captains called the site Council Bluff. In 1853, citizens of the nearby small town of Kanesville adopted Council Bluffs as their city's new name.

LEFT: One of Fort Crook's spacious 1890s-era brick officers' quarters is located on Generals Row, reserved for the top officers at Offutt Air Force Base. The base is the headquarters of STRATCOM, a unified command controlling the nation's nuclear weapons.

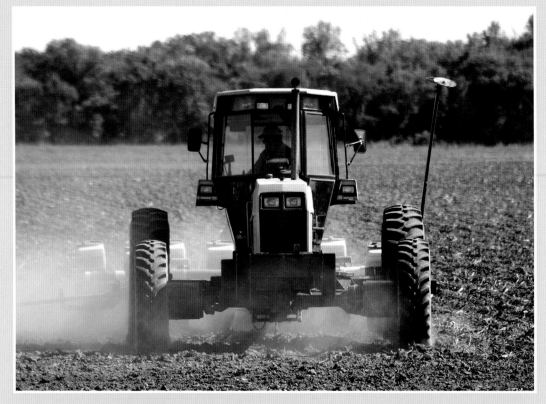

ABOVE: A farmer sows seeds in a field in western Douglas County. The county land area is 331 square miles, encompassing most of Omaha. Crops include legumes, grains, and hay.

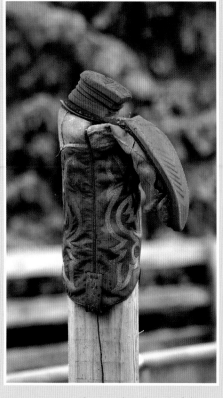

ABOVE: In a time-honored tradition of the Old West, a used boot finishes out its life on a fencepost alongside a pasture north of Omaha. Although no definitive explanation exists, some say boots placed this way ensure a cowboy's "sole" is always facing heaven.

FACING PAGE: Plowed fields in springtime create a patchwork of solids and swirling geometrics on the farmland west of Omaha.

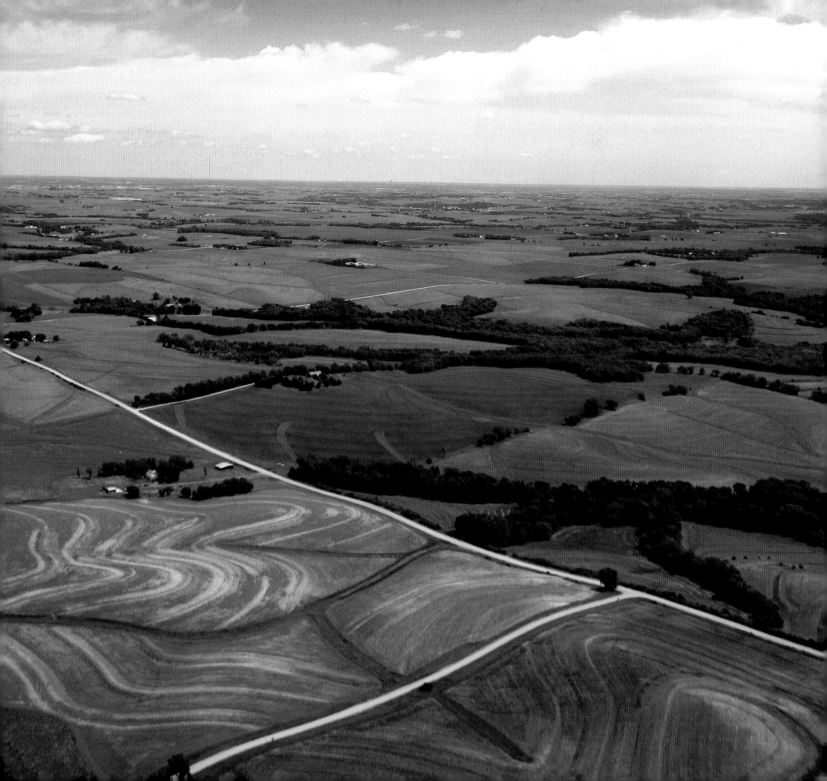

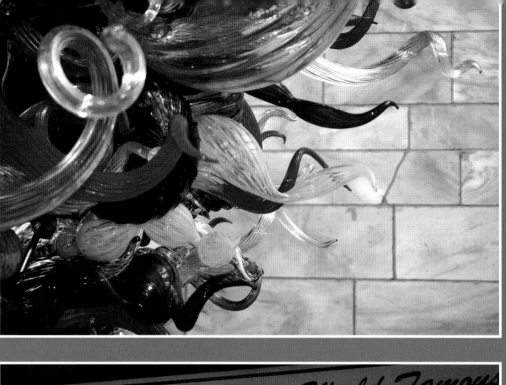

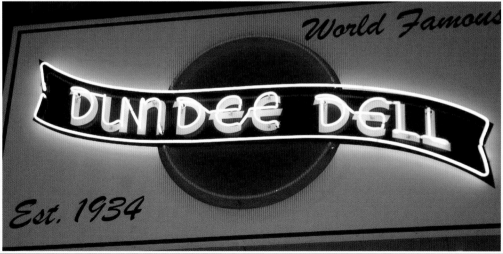

ABOVE, TOP: Dale Chihuly's colorful glass creates loops and swirls against a backdrop of pink marble panels at Joslyn Art Museum. The Joslyn is known for its collection of art of the American West.

ABOVE, BOTTOM: The Dundee Dell has long been a favorite place for a meal or a drink for many Omahans. One story tells that its popular Reuben sandwich was created in the 1920s by Reuben Kulakofsky, of the Blackstone Hotel, when a guest asked him to whip up a late-night snack.

FACING PAGE: A burst of flame shoots hot air into the envelope of a colorful balloon carrying passengers for a sky-high ride across southwest Omaha.

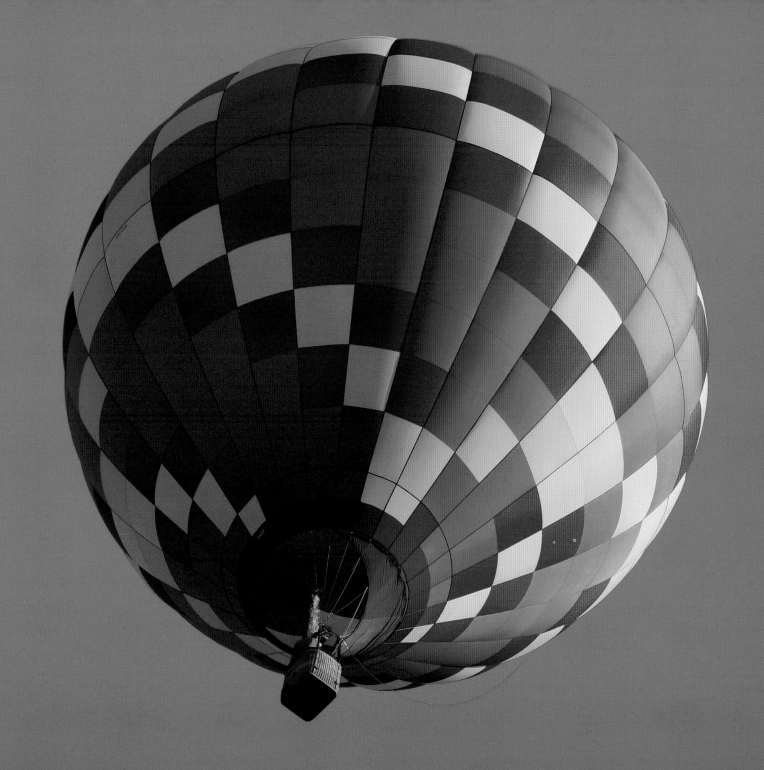

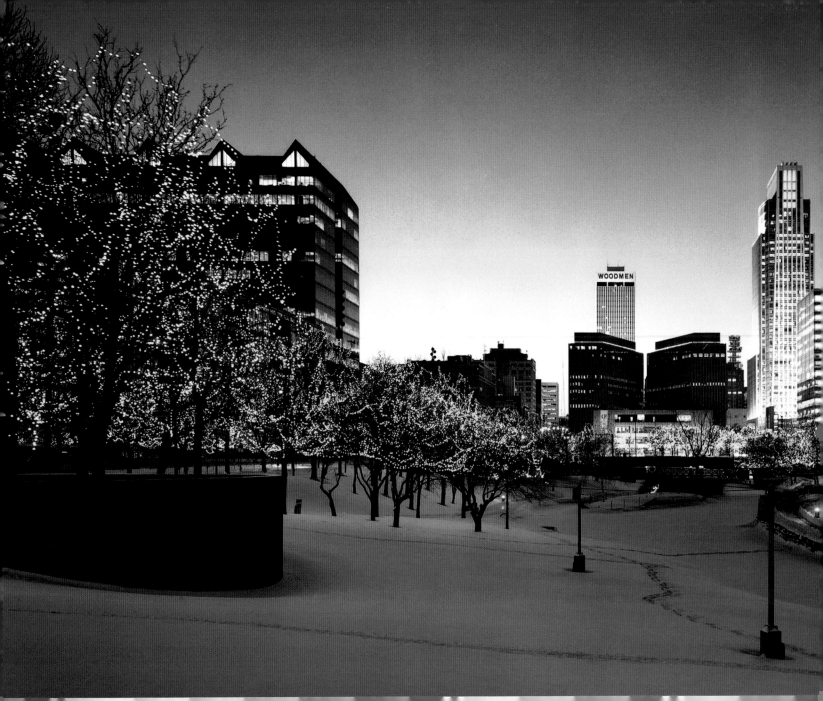

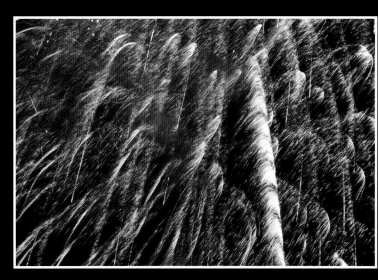

ABOVE: Feathery fireworks arch across the night sky during the annual Fourth of July fireworks display at Rosenblatt Stadium.

LEFT: More than a million seasonal lights create a sparkly winter wonderland in the Gene Leahy Mall during the Holiday Lights Festival; surrounding office lights lend additional glow to the holiday scene.

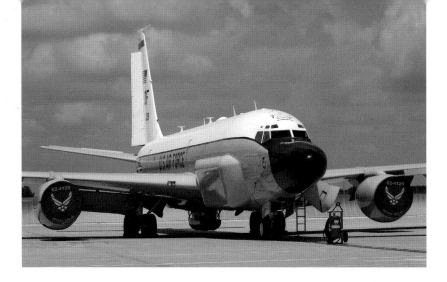

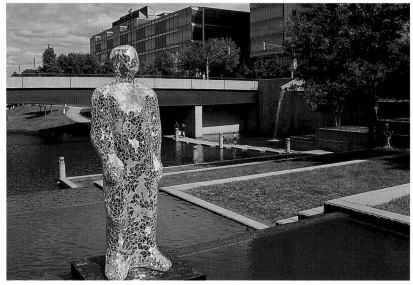

ABOVE, TOP: An RC-135 waits on the ramp at Offutt Air Force Base for its next mission. This model and others at Offutt have taken crews on a variety of aerial reconnaissance missions around the globe since the 1960s.

ABOVE, BOTTOM: Covered with thousands of tiny mirrors, *J. Doe* watches the water in the Gene Leahy Mall. More than a hundred of the six-foot-tall, gender-neutral figures were positioned around the city after each was decorated by an area artist.

RIGHT: The curving lines of the structures and drives of Memorial Park gleam white against the green hues of the lawn and trees. Thousands of enthusiastic listeners come to concerts held on the slope seen here at the left of the photo.

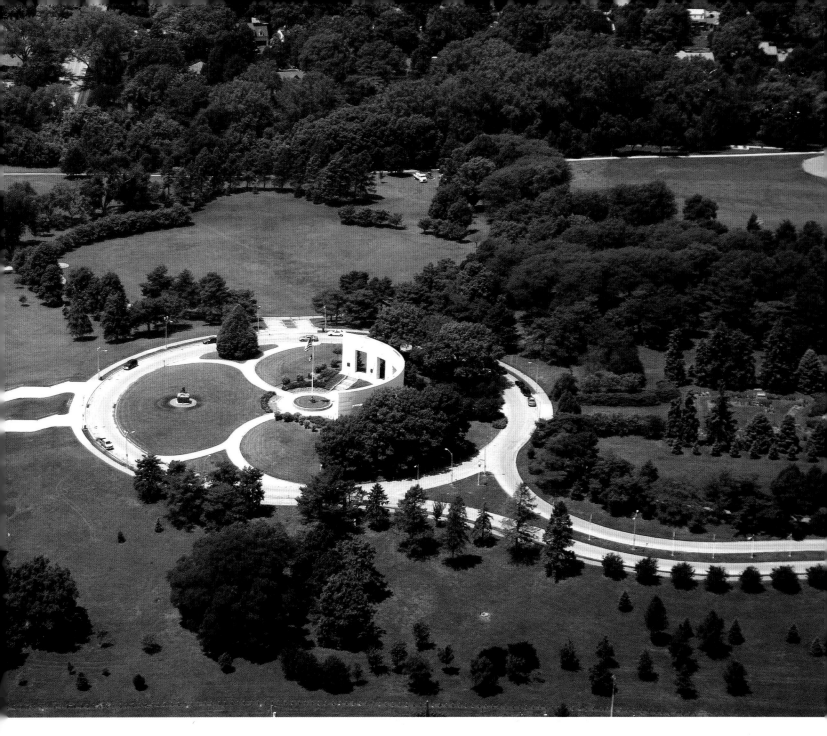

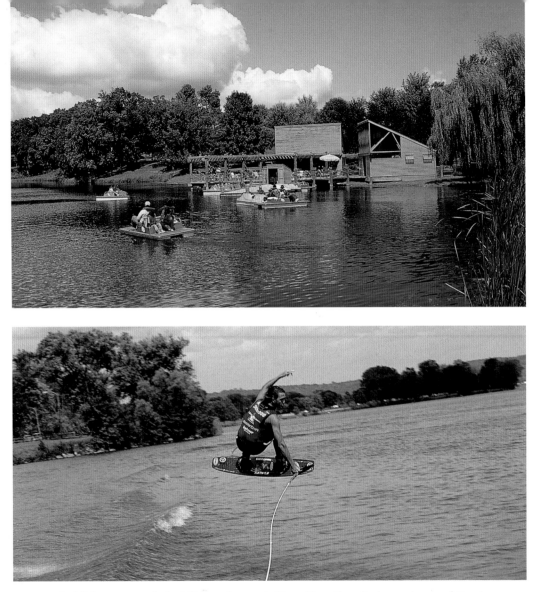

ABOVE, TOP: Paddleboaters test their skills on a lagoon in Platte River State Park, southwest of Omaha.

ABOVE, BOTTOM: A wake boarder flies during competition on Carter Lake. Originally a bend in the Missouri River, the lake was formed in July 1877 when floodwaters cut a new channel and created an oxbow lake. The 320-acre body of water first was called Cut-Off Lake, then Lake Nakomis, and finally Carter Lake.

RIGHT: Members of the Creighton Women's Rowing Team pause during a training run on Carter Lake, site of collegiate rowing competitions each spring.

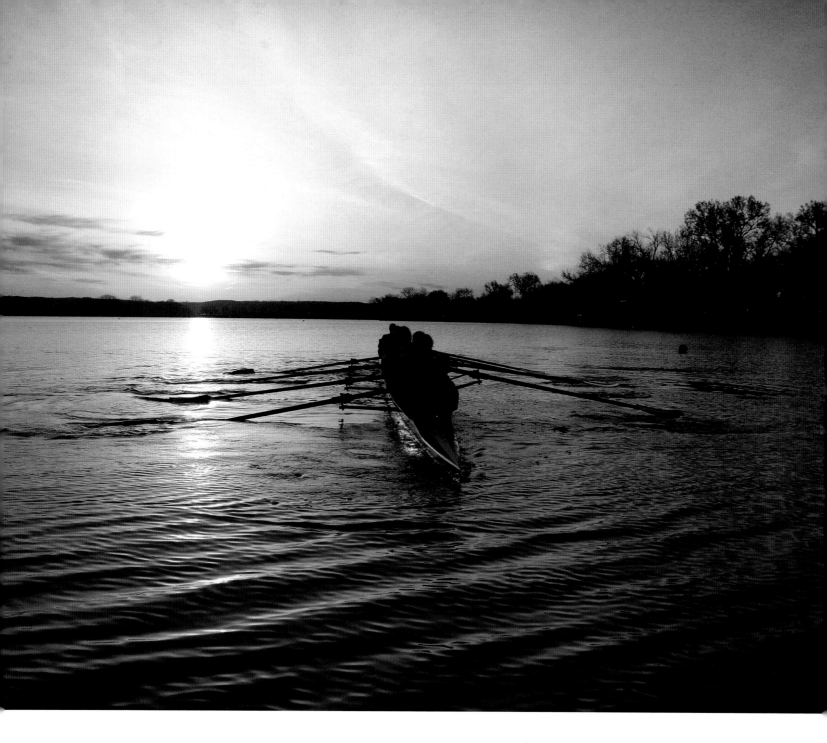

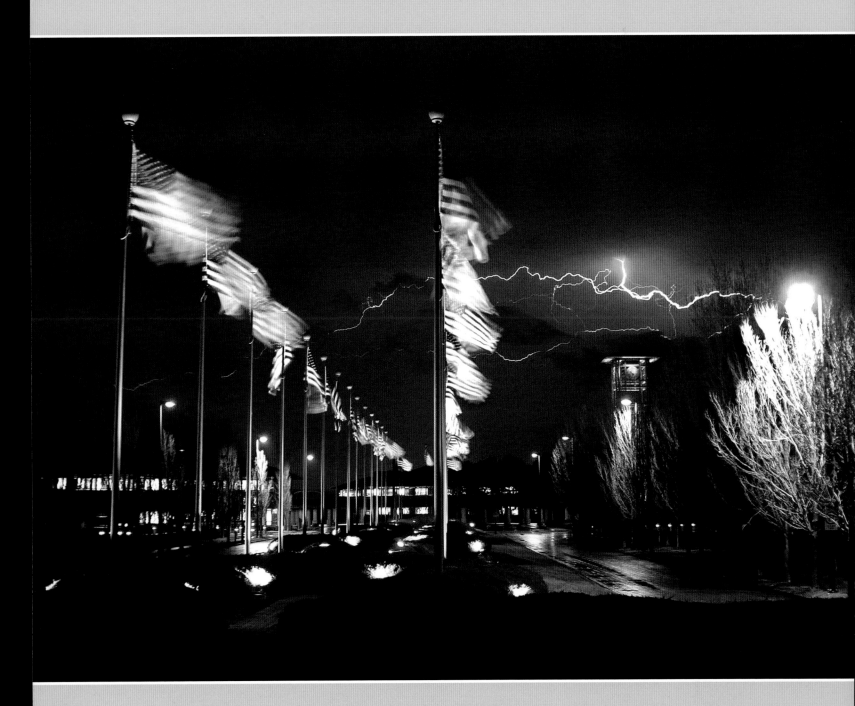

ABOVE: The formal rose garden and colonnade fashioned after the White House grace the grounds of the President Gerald R. Ford Birthsite and Gardens.

LEFT: Lightning fills the sky behind an avenue of flags as a spring storm thunders across the metro area.

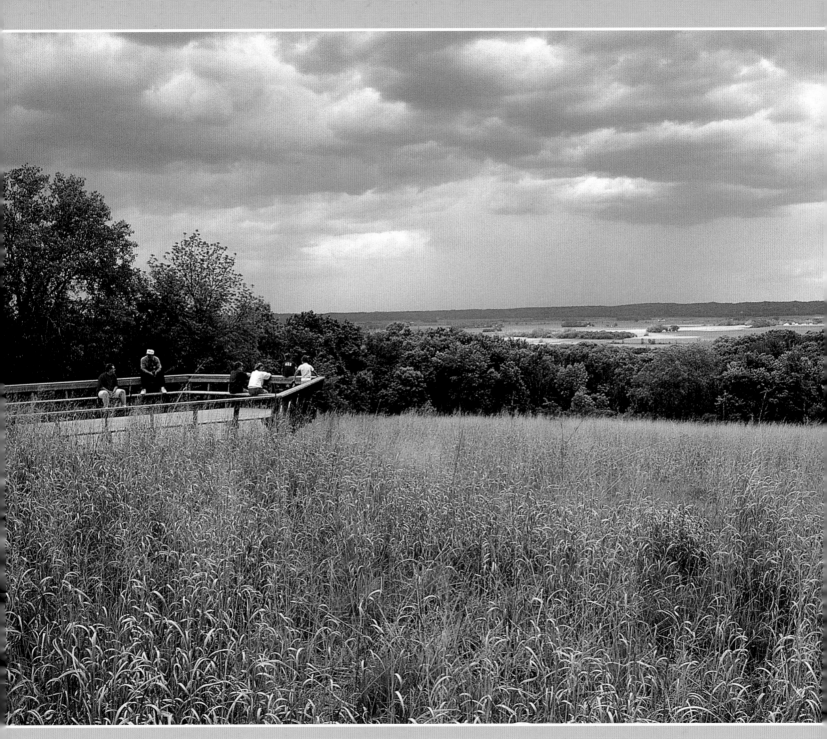

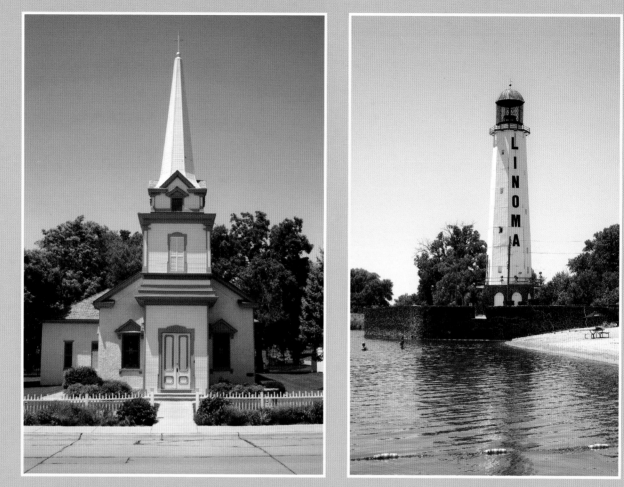

ABOVE, LEFT: The original 1856 First Presbyterian Church in Bellevue forms the oldest church in Nebraska. The congregation moved into a newer building years ago, but the old church still hosts several weddings each year. Incorporated in 1855 on the south side of what would become the metro Omaha area, Bellevue is Nebraska's oldest city and, with a population larger than 50,000, the state's third largest.

ABOVE, RIGHT: One of Nebraska's rare lighthouses casts its reflection across the waters at Linoma Beach Resort, a privately run recreation area near the Platte River. The 110-foot-tall tower is halfway between Lincoln and Omaha, hence, its name Linoma.

LEFT: Visitors to a parcel of preserved prairie at Neale Woods Nature Center take in a view of the wide Missouri River valley north of Omaha.

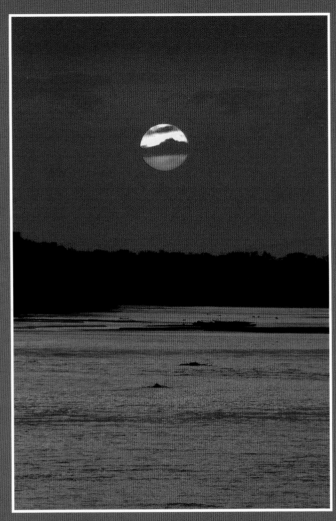

ABOVE: Clouds cross the disk of the setting sun beyond the Platte River. Carrying waters from the Rocky Mountains in Colorado and Wyoming, the Platte travels the length of Nebraska and joins the Missouri River south of Omaha.

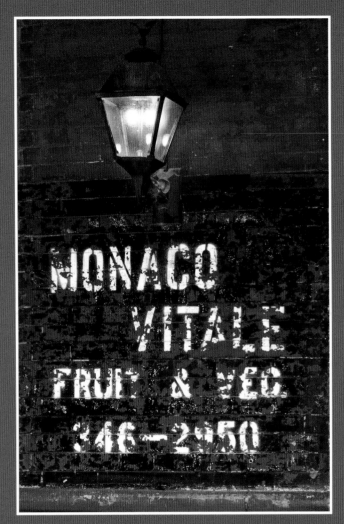

ABOVE: A vintage lamp in the Old Market shines near a sign painted decades ago to advertise a former produce vendor. Restaurants, boutiques, specialty stores, and upscale condos and apartments now occupy the area.

FACING PAGE: Named after the shape of an old clothes iron, the triangular-shaped Flatiron Building is one of the more unique buildings in Omaha. Built in 1912, it first served as a hotel. Now it houses offices and, on the ground floor, the highly touted Flatiron Café.

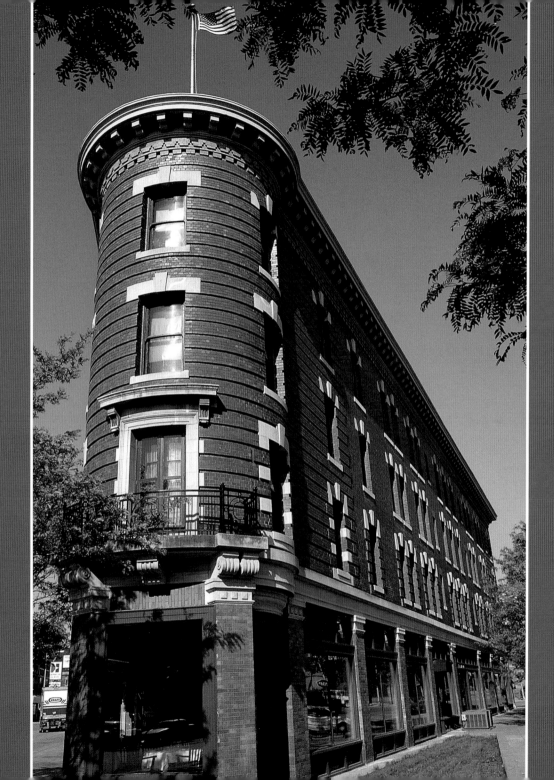

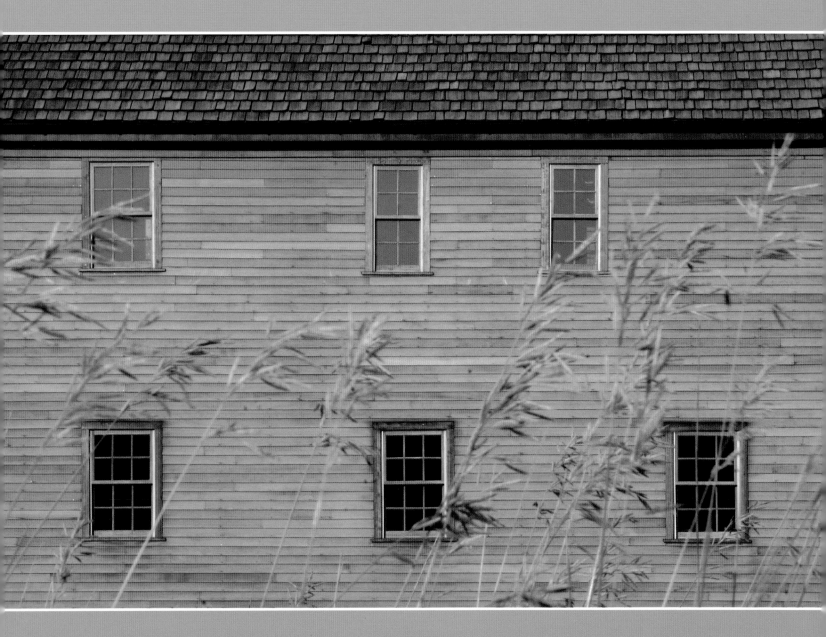

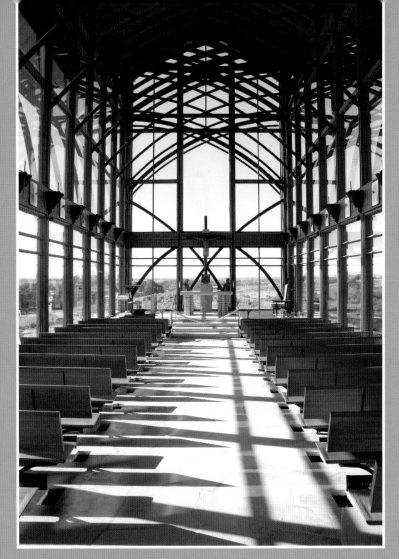

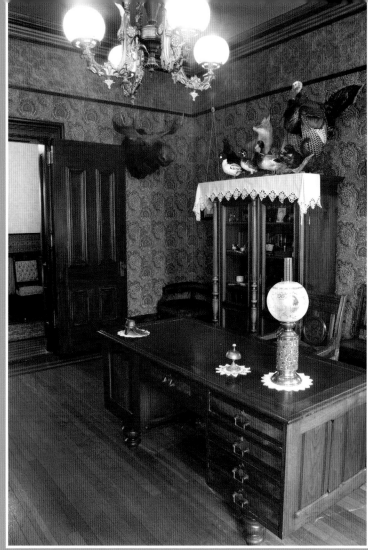

ABOVE: The spacious glass walls of the Holy Family Shrine, southwest of Omaha, bring views of the prairie and the Platte River Valley into the airy countryside chapel.

FACING PAGE: Built in 1847 by Mormons, at the direction of Brigham Young, the Weber Mill in the Florence neighborhood is one of Omaha's oldest structures. Also called the Florence Mill, it operated until 1970 as one of the city's oldest businesses. Now listed on the National Register of Historic Places, the mill houses a museum and artists' loft.

ABOVE: This study, used by General George Crook (one of the U.S. Army commanders to whom Geronimo surrendered) is much as he might have had it arranged. The 1879 house is preserved as the General Crook House Museum at the former Fort Omaha. It also houses the Douglas County Historical Society.

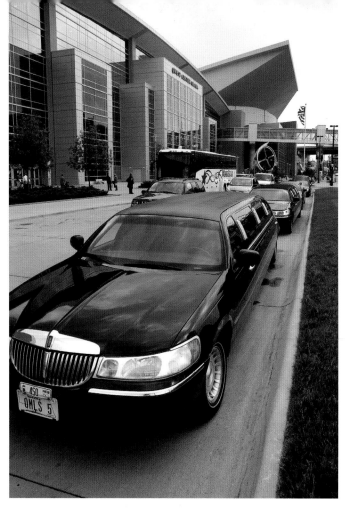

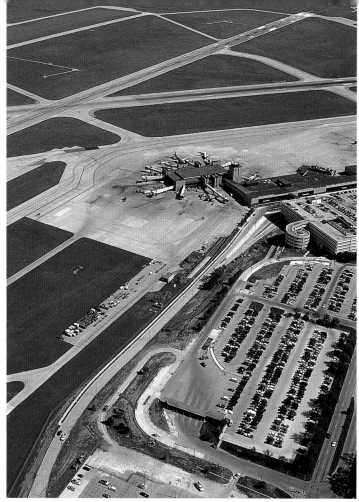

ABOVE: Limousines await those attending an annual stockholders meeting of Berkshire Hathaway in the Qwest Center Omaha. There, they listen to Chief Executive Officer Warren Buffett. One of the world's richest men, Buffett lives and works modestly in central Omaha.

ABOVE: Runways and taxiways create a web of interlocking routes at Omaha's Eppley Airfield. More than 90 flights a day carry more than four million passengers in and out of Omaha annually.

FACING PAGE: An ornate feature of the 1906 Brandeis Building frames the simple and clean lines of the new 45-story One First National Tower, completed in 2002. The 633-foot-tall center is the tallest building in Nebraska, and the tallest between Chicago and Denver.

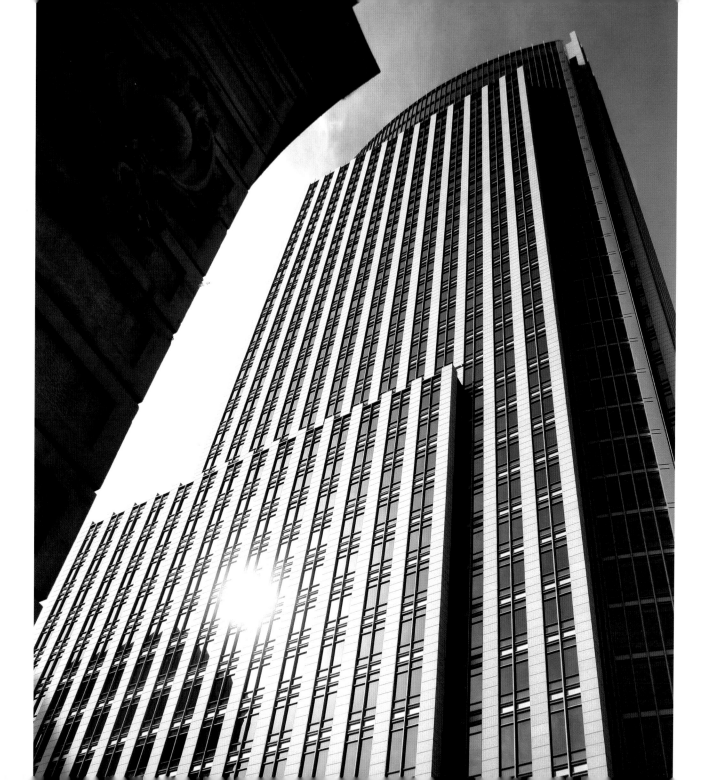

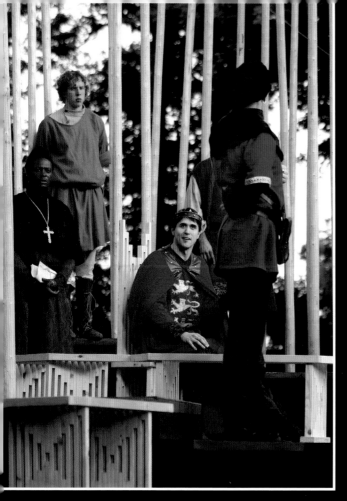

ABOVE: Actors play in a scene from *Henry V* during a Shakespeare on the Green performance in Elmwood Park. Every June and July, thousands of people enjoy two Shakespeare plays set in a natural amphitheater in the park, produced by Nebraska Shakespeare.

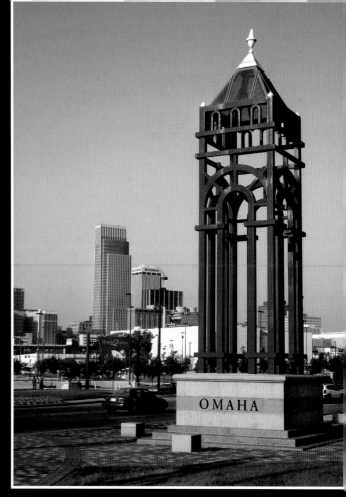

ABOVE: One of a series of smart-looking gate towers welcomes travelers from Eppley Airfield to downtown Omaha.

FACING PAGE: Framed by a one-third scale replica of the Sunpu Castle gate, a pair of red torii gates create a peaceful setting at the Japanese Garden in Lauritzen Gardens. The garden symbolizes the relationship between Omaha and Shizuoka, its sister city in Japan, which donated the gate as well as the granite shrine on top of the hill.

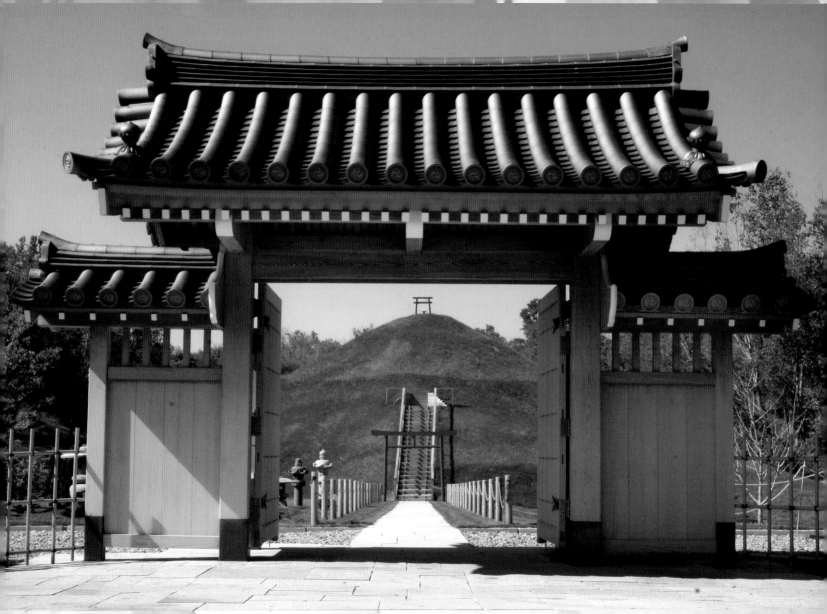

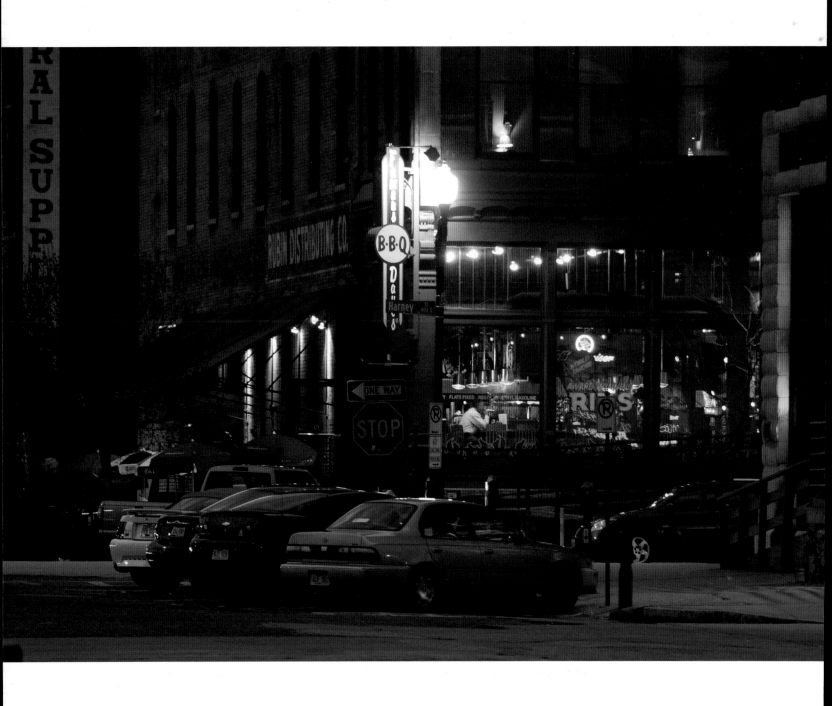

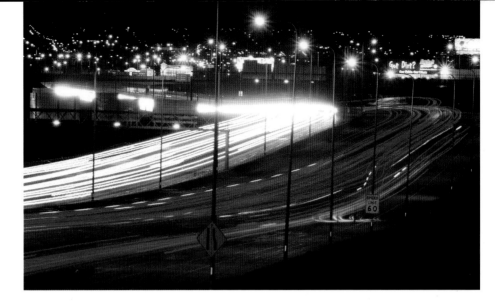

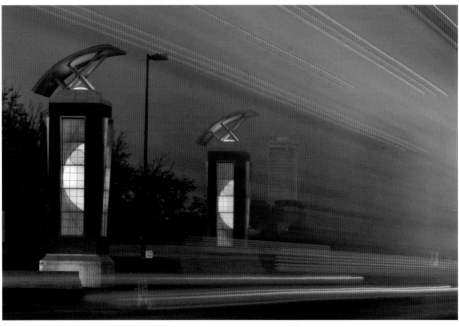

ABOVE, TOP: A long nighttime exposure of headlights and taillights reveals a surreal likeness to loose strands of red and white ropes rounding a curve on Interstate-80, in Omaha.

ABOVE, BOTTOM: The running lights of a passing truck streak through a pre-dawn scene of the ever-changing, colorful gateways in western Council Bluffs. In the distance are buildings in downtown Omaha.

LEFT: The cool shadows of evening can't put out the warm, glowing lights that beckon visitors to the Old Market historic district.

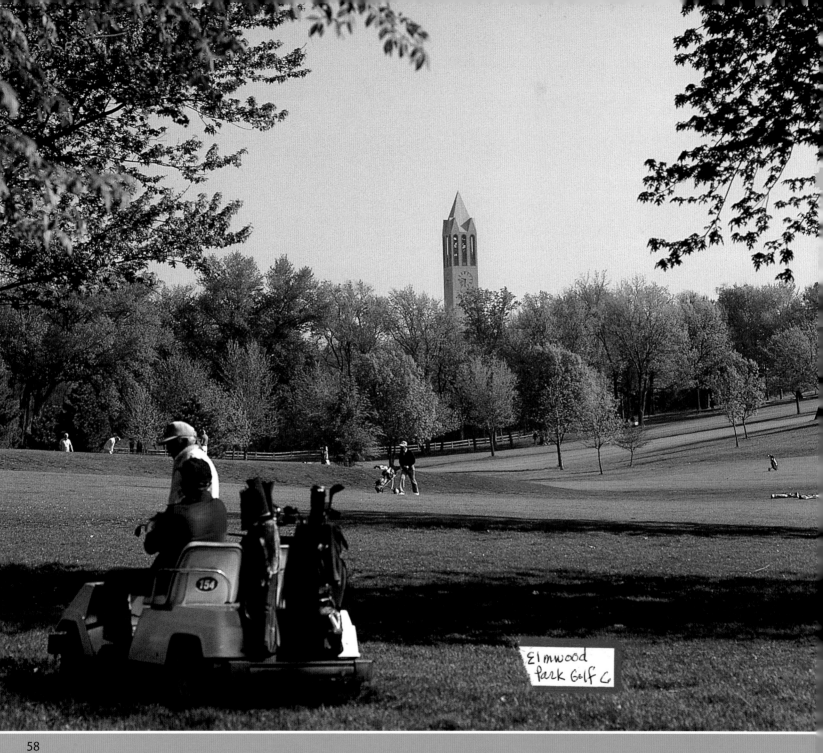

Elmwood
Park Golf Co

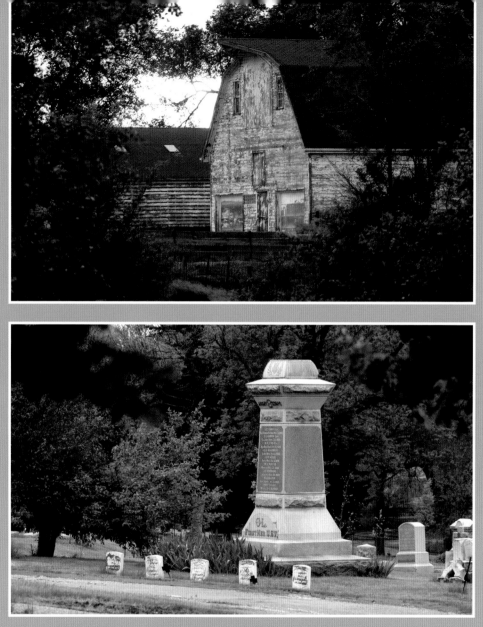

ABOVE, TOP: Sunset casts its last light on a barn in southern Sarpy County.

ABOVE, BOTTOM: In use since 1858, Prospect Hill Cemetery is the city's oldest. The large memorial honors those who died in the Spanish-American War.

FACING PAGE: Golfers take to the fairways and greens in Elmwood Park, nearly within the shadow of the 168-foot-tall campanile on the campus of nearby University of Nebraska at Omaha.

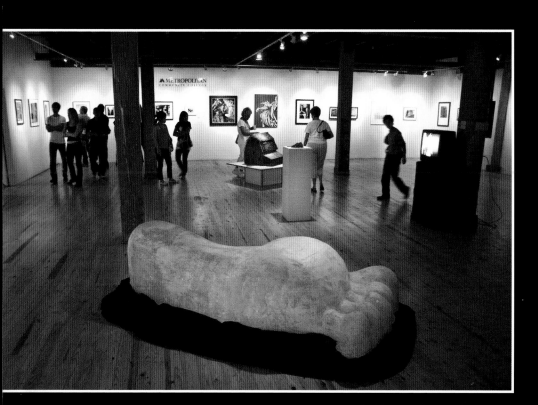

ABOVE: A giant sculpture maintains a toehold in a gallery in the Hot Shops Art Center. The center holds fifty art studios, as well as four art galleries and several exhibition spaces.

RIGHT: Dimmed by clouds, and mist rising from the Missouri River, the morning sun shines on the 222-foot-tall spires of Saint Cecilia's Cathedral. One of the ten largest cathedrals in the United States when it was built in the early twentieth century, the cathedral also hosts interfaith visual and performing arts events each year.

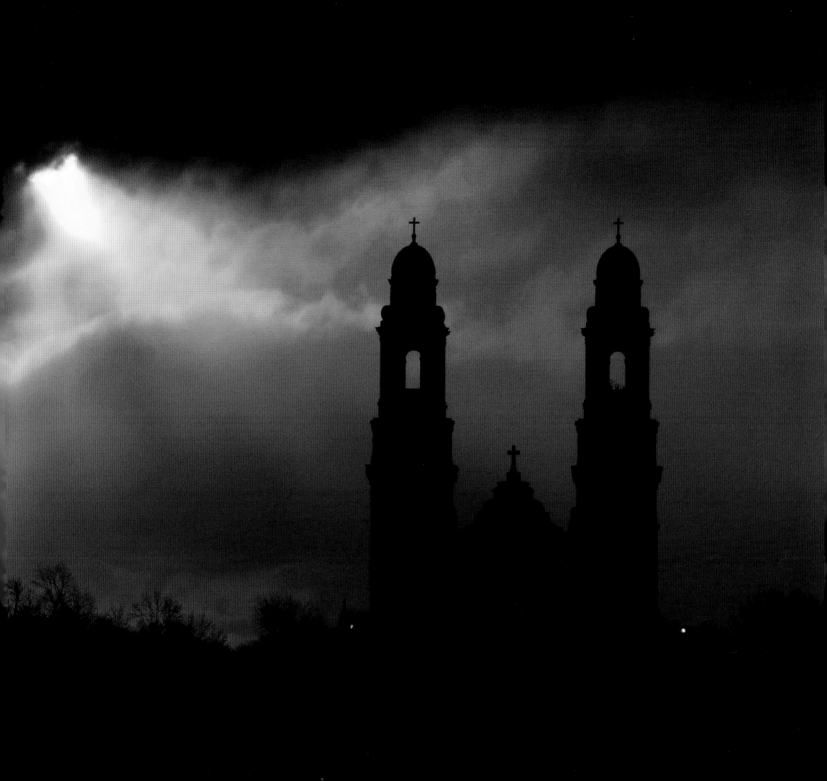

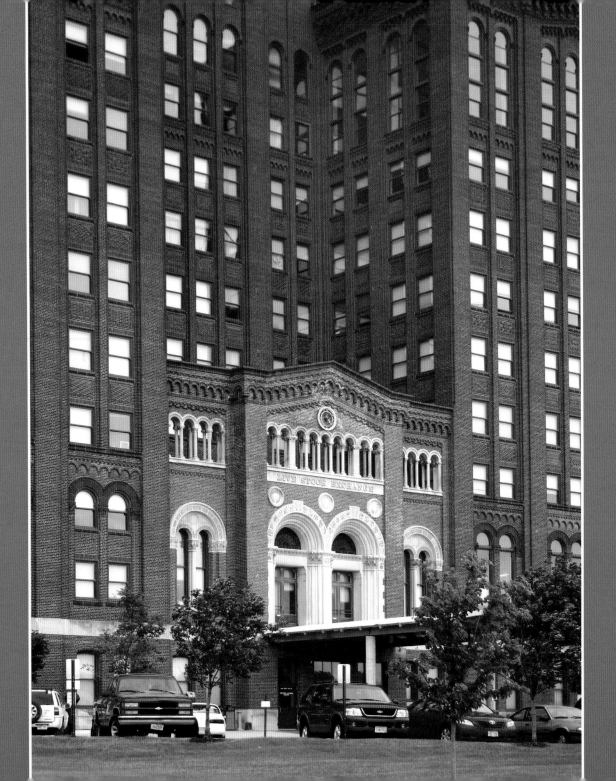

ABOVE, TOP: A student reads in a cozy setting at the University of Nebraska at Omaha. On top of the inner steps are ceramic dangos (meaning "dumplings") created by Japanese artist Jun Kaneko, who now resides in Omaha.

ABOVE, BOTTOM: Mama Bear, Papa Bear, Baby Bear…These chairs in the Dundee–Benson area of Omaha await the right sized inhabitants.

FACING PAGE: Perhaps the best-known building in South Omaha, the 1926 Live Stock Exchange loomed over the Union Stockyards, which were the largest in the nation between 1955 and 1973 and employed up to half of Omaha's work force. In its heyday, the exchange held offices, apartments, sleeping rooms, convention centers, ballrooms, a cafeteria, bakery, and more. Now remodeled, the structure retains the ballrooms on top of the two towers, and has more than a hundred housing units.

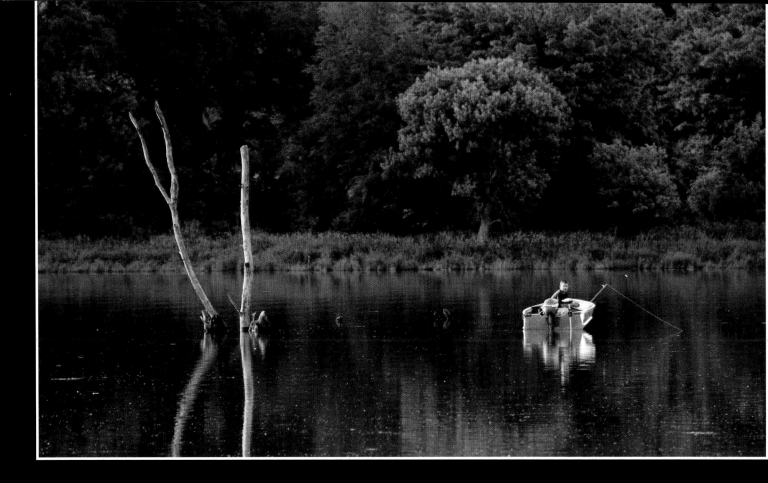

ABOVE: A fisherman waits for a bite while floating amid reflections on Zorinsky Lake. The 255-acre lake is a popular spot for relaxing in western Omaha.

RIGHT: Cucumbers stay fresh under a moist burlap covering, awaiting their turn to be displayed at a farmers' market.

FACING PAGE: Mormon Hollow is typical of the many valleys that lace the heavily wooded hills of Fontenelle Forest, a nature preserve in Bellevue. With more than 1,400 acres and 26 miles of trails leading through forest, prairie, and wetlands, the preserve is a favorite of hikers and birdwatchers.

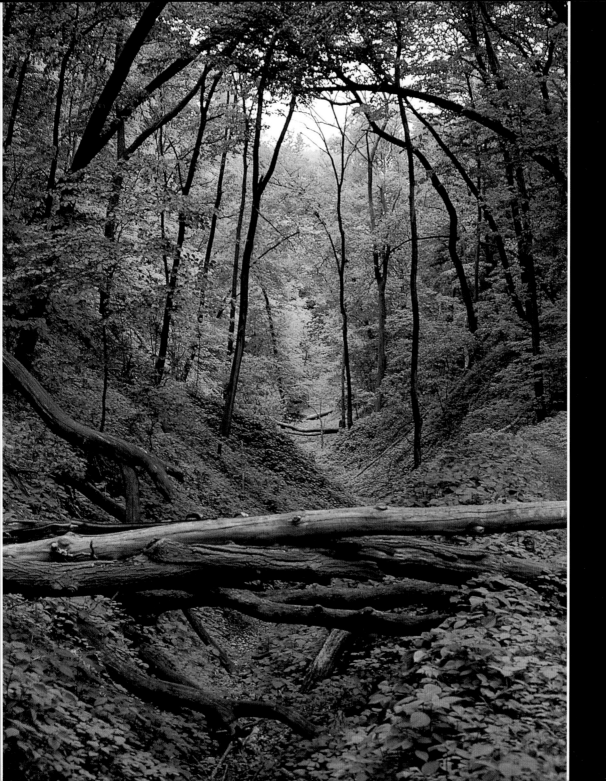

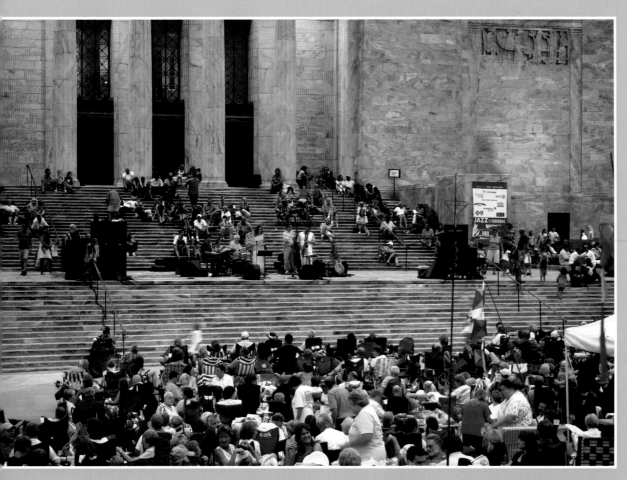

ABOVE AND RIGHT: Inside and out, Joslyn Art Museum is one of Omaha's great places. A gift from Sarah Joslyn in 1931, the museum shows its Art Deco styling throughout, as evidenced by the courtyard that features a fountain of colored tile, flanked by galleries featuring works from the permanent collection and traveling exhibits. Each year, in July and August, the Joslyn hosts "Jazz on the Green," where musicians perform on the front steps for thousands of people who spread out across the museum's lawn.

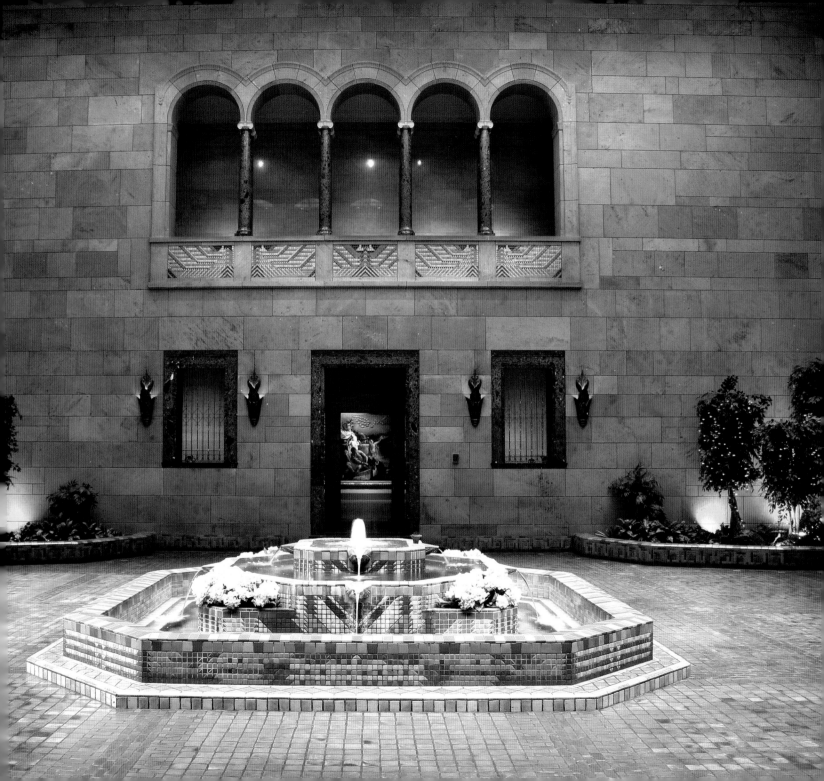

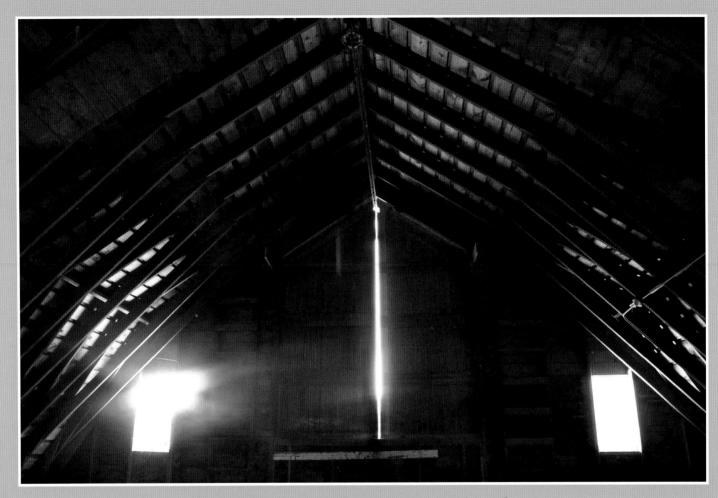

ABOVE: Sunlight leaks into the Ackerhurst Dairy Barn northwest of Omaha, revealing the stout underpinnings of its roof. Built in 1935, the 193-foot-long, Dutch gambrel roofed barn is said to be the largest wooden barn in Nebraska. The lower area of the barn is rented out for special events.

FACING PAGE: The morning sun bursts through a tree and streams across a lawn at Levi Carter Park, located on the edge of Carter Lake.

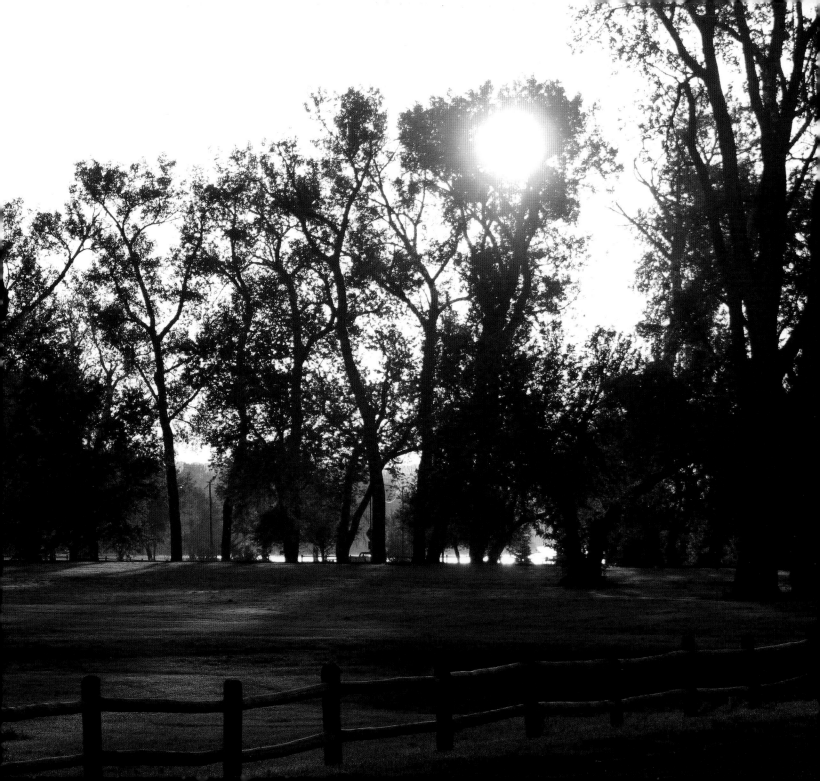

RIGHT: Approaching stormclouds create an eye-catching skyline underlying the spectacular sunset beyond a line of trees in Ponca Hills.

BELOW: Delicate clouds embrace the moon as it rises above the Platte River near Louisville. The river was called *Nibthaska* by the Omaha, and *Nibrathka* by the Oto; both words mean, "flat water." The word Nebraska was used as the name for the territory, and again for the state when it joined the United States in 1867.

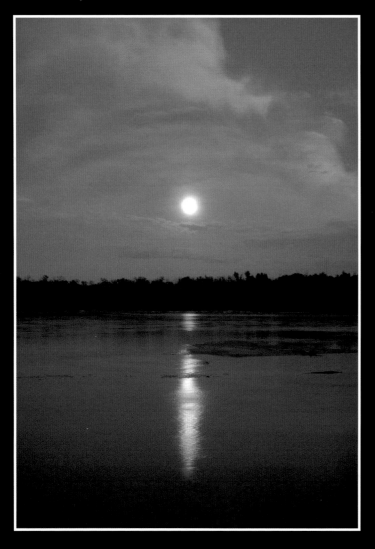

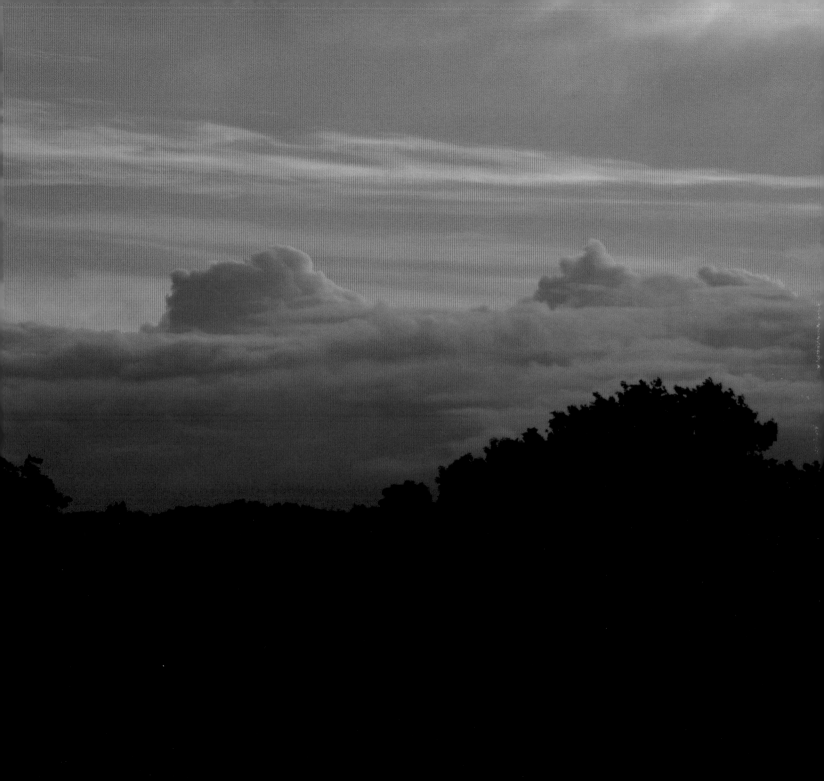

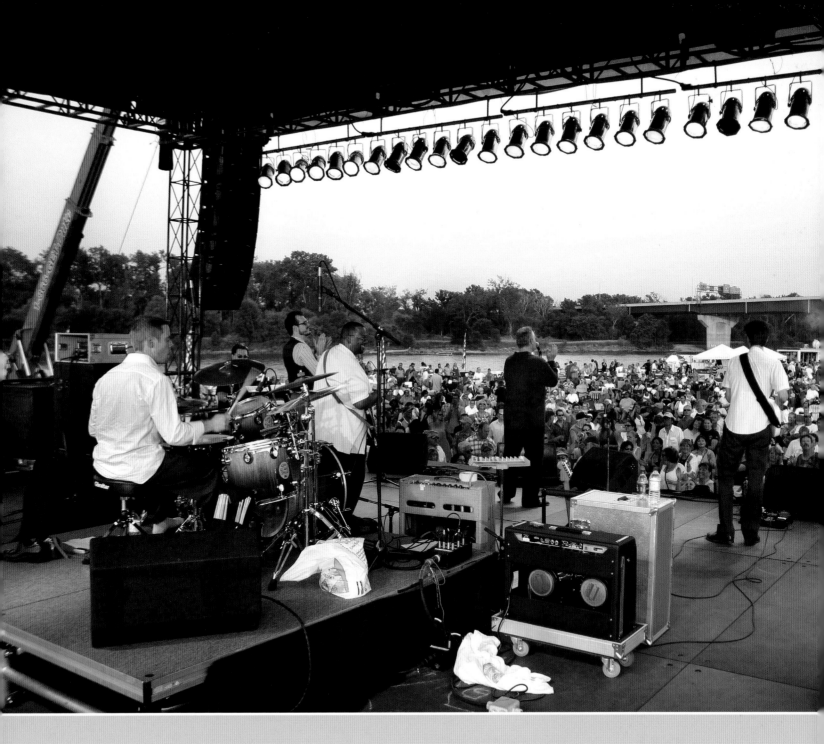

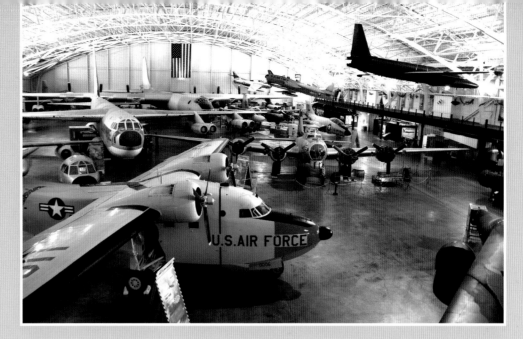

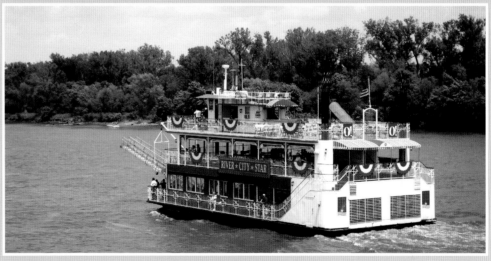

ABOVE, TOP: Military aircraft that played various roles in the nation's strategic airpower from World War II to the present occupy a hangar at the Strategic Air and Space Museum southwest of Omaha.

ABOVE, BOTTOM: The *River City Star* churns up the Mighty Mo to its dock near Miller's Landing. The excursion boat offers sightseeing, theme, and lunch or dinner cruises.

LEFT: Lively music always attracts an audience at Millers Landing, next to the Missouri River. The plaza is near where William Brown operated his Lone Tree Ferry, bringing people to the west side of the Missouri in the 1850s to settle an area where he envisioned a city would one day rise from the prairie. How right he was!

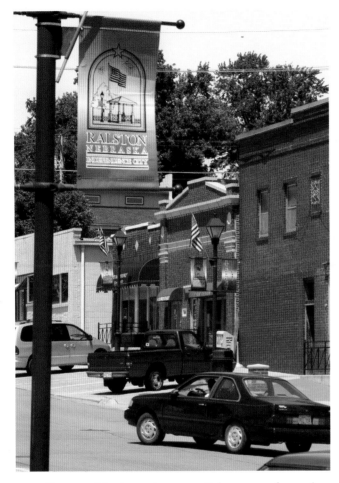

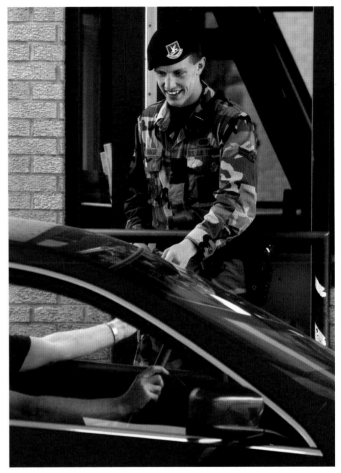

ABOVE: Banners add color to downtown Ralston, one of several smaller communities that are part of the metro area.

ABOVE: A security guard checks the identification of a woman entering Offutt Air Force Base near Bellevue. With nearly 10,000 civilian and military personnel, Offutt is the metro area's largest employer. The base was named for Jarvis Offutt, an Omaha airman killed in World War I.

FACING PAGE: Ten stories tall when built in 1889, the Omaha Building was the city's first skyscraper. Now eleven stories tall, the building was recently renovated at a cost estimated at $16 million, funded by its tenant, the legal firm of Kutak Rock LLP.

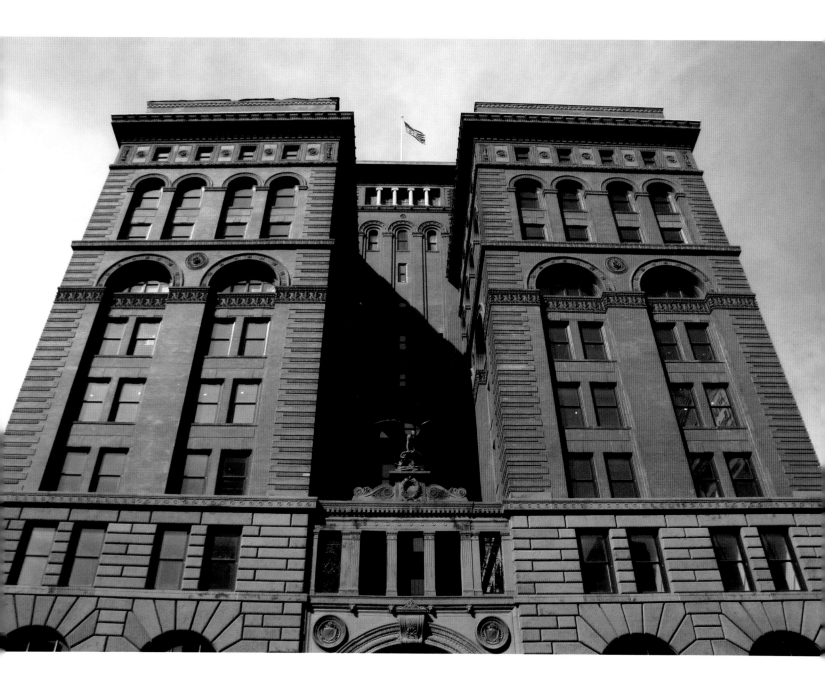

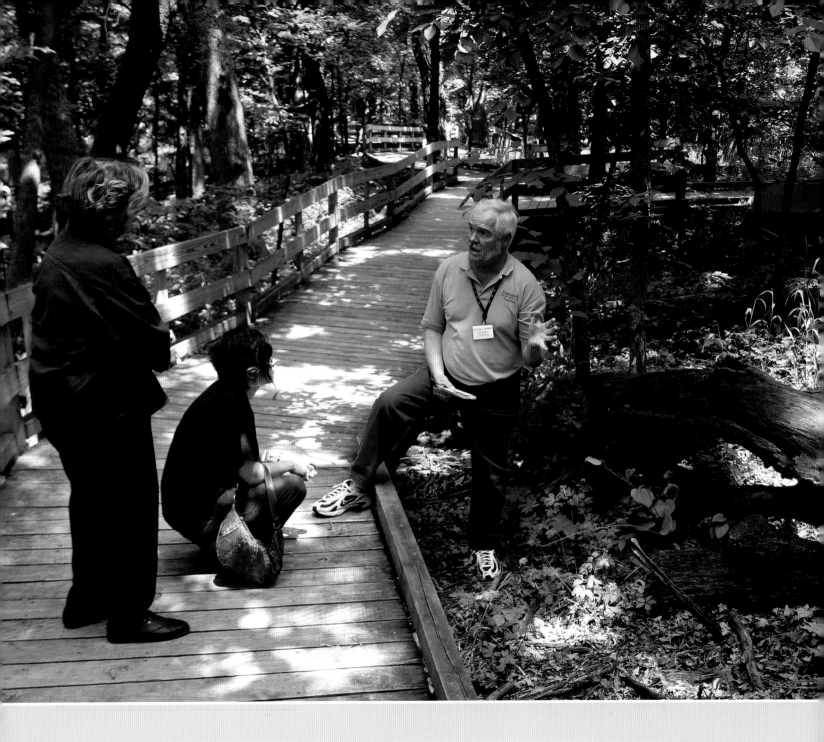

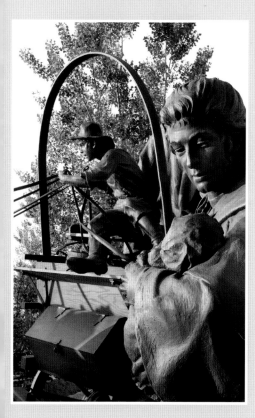

ABOVE, LEFT: Pictured here is just one scene from a block-long tableau of bronze figures called *Pioneer Courage,* by sculptors Blair Buswell and Ed Fraughton. One of the largest collection of statues in the nation, it features an ensemble of 13 westward-bound settlers, two wagons, teams of horses and mules, and a milk cow.

ABOVE, RIGHT: The Douglas County Courthouse, built in the early twentieth century, is the county's third courthouse. It was designed in the Renaissance revival style popular at the time.

FACING PAGE: A volunteer guide talks to visitors about woodland wildflowers in Fontenelle Forest. A mile-long system of boardwalks provides barrier-free access for those wishing to be in the woods near the nature center.

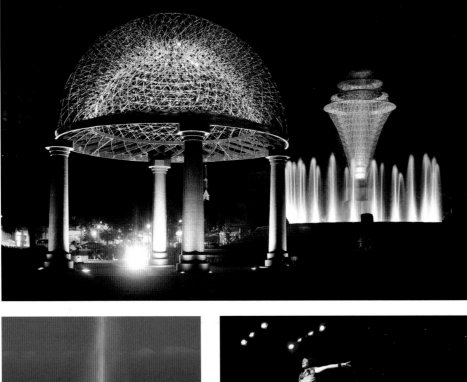

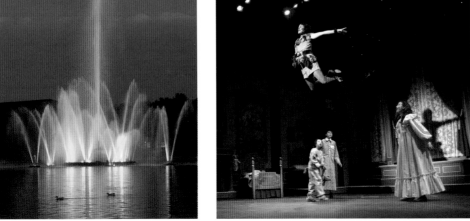

ABOVE, TOP: A unique pavilion and fountain designed by sculptor Brower Hatcher adds color to the night in Bayliss Park in downtown Council Bluffs.

BOTTOM LEFT: Lights color a spire of water soaring from the main fountain in Heartland of America Park. The 31-acre park is near the Missouri River in downtown Omaha.

BOTTOM RIGHT: Peter Pan soars in a presentation at the Omaha Community Playhouse, which touts itself as the nation's largest community theater. Actors who began their careers at the playhouse include Henry Fonda, Dodie Brando (Marlon's mother), and Dorothy McGuire.

RIGHT: The downtown skyline lights up as evening settles on the city, drawing another day in Omaha to a close.

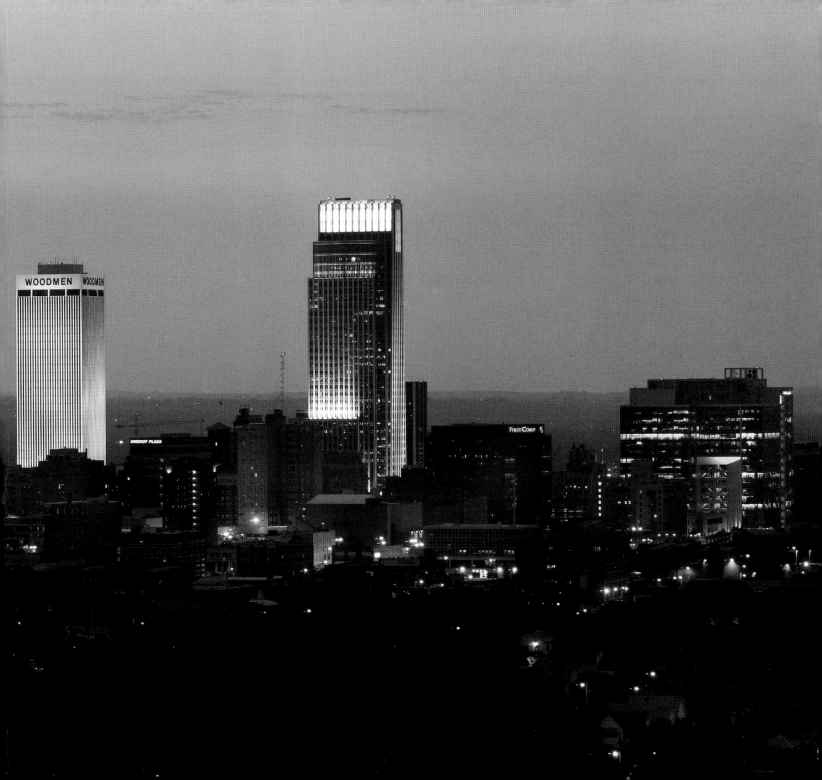

PHOTO BY DORIE STONE

MIKE WHYE'S interest in photography began when he was a teen. His hobby turned into a business that has led him across the United States, Canada, Mexico, and parts of Europe.

A self-taught photographer, Mike began freelancing full-time as a writer-photographer in 1983, after working with a newspaper in Omaha and managing the public relations of a 150-person firm in northwest Iowa. His articles and photographs have appeared in magazines as varied as National Geographic Traveler, Time, and AAA's Home and Away; regional newspapers including the Des Moines Register and the Omaha World-Herald; and with clients such as the National Park Service's HABS/HAER division, Iowa Tourism, and Nebraska Tourism. He has written and photographed two guidebooks on Iowa, on another on Kansas, and he wrote and photographed Farcountry Press's *Nebraska Simply Beautiful*.

A member of the Midwest Travel Writers Association since 1989, he has won the association's top Mark Twain Award for photography four times. Mike also teaches journalism writing and photography courses at the University of Nebraska at Omaha. He lives across the Missouri River from Omaha in Council Bluffs, Iowa, with his wife Dorie Stone, and children Alex, Meredith, and Graham. A small menagerie of animals resides with them, including a dog, cat, hermit crab, and— depending on the season—garter snakes and butterflies.